JEWISH

Artists:

on the edge

An exhibition sponsored by the
Jewish Community Council
of Northern New Mexico

Curated by:
Ori Z Soltes

Project Director:
Jay Barry Zeiger

The Marion Center and
The College of Santa Fe, Santa Fe, NM
Summer, 2000

CONTENTS

FOREWORD
Ori Z Soltes
Curator

Jewish Artists on the Edge has two primary goals. One is to explore works of art in diverse media by artists who are on the edge in any number of ways. They may be particularly original in conception, pushing the boundaries of the medium (or media) in which the artist works. The subject matter may be on the edge in engaging issues of identity, of the boundary between the artist's self and his/her Jewishness, nationality or gender, or the identity of the subject depicted. It may be an edge of comfort or discomfort. The second purpose which is informed by the first is to challenge the tendency in the art world, when the adjective "Jewish" is attached to the nouns "art" and "artist", to pre-assume parameters that are narrow and of secondary quality—certainly not on any edge—for the art or the artist in question.

There is an ax to be ground here. Consider: the work of a significant contemporary artist was recently offered to the Israel Museum by one of its major patrons, and turned down as "too Jewish"—even though the piece of work in question was not focussed on a Jewish subject at all. One portion of the artist's earlier work—exhibited at a number of major modern, non-Jewish art museums—had dealt with the Holocaust, and the relationship between past and present, loss and return, memory and forgetting. But the piece offered to the Israel Museum came from an altogether different body of the artist's work. Its focus was his childhood city, in America, but in also being attached to the issue of memory, was taken by the curator to be "Jewish"—*too* Jewish—as if only Jews chart a significant relationship between memory and art!

Too many artists who happen to be Jewish are forced to eschew any association with that part of their identity and its relationship to their art out of fear that narrow-minded curators and critics—many of *them* Jewish—will stigmatize their work with just that kind of label. Their art-making puts them on the edge—as that phrase means *uncomfortable* about who and what they are. Rising artists worry that their careers will be truncated by the kind of judgment just instanced from the likes of the Israel Museum. The concern extends to well-established artists and/or their publicists. A few years back, the widow—herself a serious and significant art educator—of a prominent color field artist whose paintings, since the 1960's, have found their way into nearly every major art museum in the world, balked emphatically at the idea that her husband's work could be construed in any way to have been informed by the fact that he was Jewish. Her concern was that if he were labeled as a Jewish artist, his work would begin to be less highly regarded. My discussing his work with her in the context of an exhibition I was planning yielded a very edgy response.

She was probably, and sadly, right. And this exhibit will certainly not solve the problem. Surely not every critic and curator, Jewish or non-Jewish, who from discomfort, latent or blatant antisemitism or simple ignorance, responds to the rubrics "Jewish art" and "Jewish artist" by immediately placing a narrow mental box around them will suddenly change perspective. This is an issue that involves the gut and the heart as much as the mind, the emotions as much as the intellect, and the human resistance to change is as alive in this matter as it is in others. Though the art world is hungry for the shock of the new it is also resistant to new ideas that challenge comfortable conceptions. But perhaps, in considering the array of efforts encompassed in the exhibit by artists some of whom are well-known and more of whom are not, the vitality of accomplishment will be unavoidable for the viewer. Some will hopefully come to see that, in varying ways, the edge between the individual and humanity's vastness can include aspects of Jewishness.

* * * * *

This exhibit would not have been possible without the help of several individuals whom my colleague Jay Zeiger acknowledges in his introduction. But all aspects of this project to which he has given 30 months of his life could not have moved in any way from start to finish without his over the edge efforts. The initial concept was his and his wisdom impacted heavily on the selection of artists, the installation of the exhibition in Santa Fe and the shaping of this catalogue. He oversaw an endless array of details and wrestled with a range of personalities, from artist-contacts to grant-writing and insurance to securing venues and supervising the initial phase of catalogue production. He, in turn, might have been overwhelmed by the mass of matters to be encompassed without the constant collaboration of Geraldine Fiskus, the third person in our trinity of exhibition-shaping. To say that it has been a pleasure, indeed great fun, to work with these two is to give new meaning to the word "understatement". If this exhibit proves, in the long run, to mark even a small change in how we think about aspects of art—if the ax ends up ground to a finer point—you guys made it happen.

And as for making things happen, I also wish to acknowledge with heartfelt thanks the commitment of time and artistic sensitivity of Madelin Coit, who made possible the move of the exhibition to Yeshiva University Museum in New York City—and with sincere gratitude to the staff of Yeshiva University Museum, in particular Curator Reba Wulkan.

Finally, I add my personal appreciation to Stan Rosen, current President of the JCCNNM for his patience and generosity of spirit. He crowned the cooperative effort which brought the final effort to fruition.

INTRODUCTION AND ACKNOWLEDGMENTS

Jay Barry Zeiger

Project Director

On Edges Boundaries. Seams. Hard. Blurred. Surface. Verge. Brink. Crossing. Visible. Hidden. Cutting. Personal. Public. Cultural. Political. Emotional. Ethical. Empathy. Esthetic. Exclusivity. Pride. Tradition. Death. Memory. Abstraction. Confrontation. Compassion. Time. Transformation. Orthodox. Hybrid. Immigration. Imagination. Sexuality. Sentimentality. Spiritual. Sanity. Sanctity. Racism. Realism. Doubt. Desire. Delving. Anxiety. Alienation. Holocausts. Millennium. Multiple identity.....

Fifty Jewish artists making art about issues of Jewish identity, making art with a Jewish sensibility and exploring universal concerns from a Jewish perspective. And, of course these issues, sensibilities and concerns are not exclusively Jewish and are shared with other cultural communities: Issues basic to human experience but qualified here by being Jewish. What we see in *Jewish Artists; On the Edge* are edges of bonding. Seams (not borders) where Jewish identity merges with other identities. This exhibition is diverse, diverse as the Jewish people themselves, who are "a nation of nations" (similar in this way to Ilan Stavans' description of the Hispanic community in his book *The Hispanic Condition*) and remain in Diaspora as a nation among nations (and communities). Because of this intricate diversity, contemporary Jewish art cannot be defined in the traditional way that the art of supposedly homogeneous cultures has been i.e. "African Art", "Hispanic Art", "Indian Art", "Japanese Art", etc. That definition is based on an emblematic style, a particular approach to design, a traditional focus on certain media, technique or form and a preference for particular subject matter. More and more we begin to see that the contemporary art of these same cultures no longer fits the traditional definition.

This same contemporary art continues to be perceived as African, Hispanic, Indian, Japanese, etc., despite its break with tradition and its consequent diversity: because it still comes out of a particular country or cultural community. Jews, on the other hand are not perceived as a homogeneous cultural community and nor do we wish to be. As a result contemporary Jewish Art remains imperceptible. Not only are Jews a heterogeneous community, this very community has been woven and still weaves itself into the fabric of other communities – and especially here in the USA. Here Jews are Americans first as we were *German* Jews or *Polish* or *Russian* Jews—unlike *Hispanic* Americans, *Native* Americans, *African* Americans etc. whose roots come first. While this condition has been imposed it has also been chosen and continues to be. The fear of being identified as a minority group holding power and wealth and the consequent risk (and history) of being targeted could be an

explanation. Today with a still healthy anti-Semitism this fear is not paranoia. The shame of the Holocaust (and history of holocausts) like the shame of the rape victim is another motive for this effacement that offers assimilation as a panacea, however tentative. Accompanied by that shame is yet another kind of embarrassment: what Donald Kuspit illustrated so vividly in his lecture at SITE Santa Fe and in his essay here following: the negative stereotype of the Jew throughout history which has too often been internalized. It is this embarrassment and guilt, a Jewish brand of original sin that many of us wish to erase.

There are some Jews who would disagree with this perspective (I heard a few protests during the course of this project), and yet the artists in this exhibition are confronting and crossing this edge of visibility and affiliation. While I heard that Jewish artists *have* been represented adequately within the mainstream of modern and contemporary art it can also be said that the vast majority of those represented have submerged their identities and motivations. Through this project I have come to see that the edge between self-censorship and Anti-Semitism is fine if not indistinguishable. Consequently, those who do not feel on the edge as Jews and those Jewish artists who "did not feel particularly Jewish" or felt that their work "wasn't Jewish in any way" are important since they are on the other side. As I write I can only propose that they are afraid to stand up and be counted along side other minorities and afraid to confront the past, complex contemporary issues and the responsibility of a Jewish future – in an explicit way. We tend to view our own ancestors as *other* because we perceive their tragic endings as humiliation. But this barrier can be dissolved as Alan Berliner urges in his *Gathering Stones*. Now we want to examine who we have become, what we believe, and whether our behavior is consistent with our multiple identities. The name *Ivri* (a Hebrew) translates as "boundary crosser" and the artists here are crossing the confining boundaries of historical Jewish identity, crossing the boundaries of our present condition and are changing the configuration of the edge between present and future identification. They are penetrating a fragile edge that has been drawn out of self–protection.

About 125 artists were invited to submit their work and were asked to write about how their work might be informed by their experience as Jews or why they felt their work should be seen in this context. Originally not intended for publication, these writings are so poignant that excerpts have become part of this catalog. "How can my work not be Jewish? It results from everything that I am and being Jewish is not an insignificant part of that."—became a motif especially among the artists who were not doing obviously Jewish work. They saw the potential in *Jewish Artists: On the Edge* to finally show them how, why and where they belonged among Jewish Artists. They anticipated that Curator, Ori Zarah Soltes, would extract some basic Jewish metal from the ore of their work. I believe that Ori was successful and I see the edges expressed and explored in the work of these artists as "veins" in the ore.

The Jewish condition first came into focus for me in 1992 when, during an NEH *Institute on the Texts of* analysis of the Jewish situation in Spain prior to the Inquisition, I had a vision of my grandmother making Blintzes! The pancakes with their thin delicate brown edges,

throughout the kitchen were filled and then folded in a complex way. When she was finished those thin brown edges had been intricately woven into the center and were no longer visible. This I realized was how the Jews were so uniquely marginalized in Spain as well as here in the USA: A form of marginalization, imperceptible not only to the larger community but to many Jews themselves. Hence the impression that we are not at all marginalized and not really a minority! Finally, the perplexing sense of feeling different while believing that "we are the same as everyone else" was clear to me.

Then followed a progression of events that led to an 8 month artist's residency at the Arad Arts Project in Israel. I returned the following year for a 2 month residency in Rehovot, sponsored by the M. Smilansky Cultural Center. As a site-specific installation artist I explored, researched and networked in the region as I had done the previous year where the program's agenda had been exposure to the cultural, political, natural, historical and spiritual environments of Israel. Shortly after returning home in 1995 to Nambe, a pueblo and old Hispanic village just north of Santa Fe, I became interested in the burgeoning Crypto-Jewish awareness in New Mexico and was invited to do an installation project on it by the CCA in Santa Fe in 1997. I spent 3 months networking in northern New Mexico and Albuquerque and produced the installation *Resistance* from a first hand understanding of fragmented and multiple identity and the realization that the Crypto-Jewish experience is quintessentially Jewish. In 1998 I curated the exhibition *Intersection Aleph* in Santa Fe at Cloudcliff Bakery & Artspace, a public (not Jewish) space and chose 5 artists including myself. The title *Jewish Artists* for me called up paintings of old Rabbis (like the paintings of old wrinkled Indians), watercolors of the *Western Wall* (like the watercolors of Paris street scenes) and cliché Holocaust drawings of skeletal stick figures and smoke stacks. Yet I knew from my experiences in Israel of a body of personal and meaningful Jewish Art happening there. Rather than *Jewish Artists, Intersection* referred to work that was addressing issues of Jewish identity at a point in time and space and *Aleph* designated my first experience as a curator of serious Jewish Artists.

In the spring of '99 just before a tour of Eastern Europe I became Project Director for the Jewish Community Council of Northern New Mexico in Santa Fe. Leah Kellogg, President, and the board of the JCC-NNM expressed many different opinions of this event at first, ranging from a Jewish Arts & Crafts fair to an international competition. Some saw it as a fundraiser open to any and all Jewish artists while others envisioned artists of international recognition with foundation funding etc. And some thought it could be both! The reality that this event could frame Jewish identity for the entire community of Santa Fe and beyond, soon became evident. As a result, the event grew in significance, scope and responsibilities. Producing an exhibition that would present the complex and evolving nature of being Jewish to the public and the Jewish Community itself was challenging and at times a source of anxiety. But for those of us who brought *Jewish Artists: On the Edge* to fruition, gratification came from presenting contemporary Jewish identity in the most authentic way, and from the quality of the exhibition that we believe to be an important contribution to the ongoing dialogue around identity and diversity.

What is Jewish Art was the first question and the usual discussion ensued. To eliminate any doubt we limited the project to Jewish artists. But was that enough to make it Jewish Art? That was a moot point but we did know we didn't want pictures of Indians or generic landscapes in this exhibition even though these expressions of false identity and anonymity could certainly be considered quite Jewish! We expected some of the work to have obvious Jewish references but content is not simply subject matter and could be subtle and subjective. We knew without question we wouldn't limit the work to Jewish subject matter and apparently were attempting to define Jewish content. The artists had to be identifying (in their work) with something Jewish. Who decides whether that "something" is Jewish: the artist, the viewer, the curator? In the end it seemed that the notion of Jewish content would probably come about through a mysterious interaction of all three. We didn't know what we were looking for, how to find it or who would recognize it! Having discussed the idea of creating a context (and how that can change the meaning of a work of art) we decided to ask the artists to submit text about their motivations and speculations regarding their work as part of *Jewish Artists: On the Edge*. We realized that Ori Z. Soltes could and would also create a context with his choices for the exhibition as well; indeed selecting him to be the curator was an acknowledgement that the project should reach as far as possible. And the audiences' context, or what they did or didn't identify as Jewish would be the wild card in the equation.

Before approaching Ori and The College of Santa Fe as the site, and attracting the artists and financial support for *Jewish Artists: On the Edge*, goals had to be articulated. Why were we doing this and who were we doing it for? "Exploring and elucidating concerns of contemporary Jewish identity through the lens of contemporary visual art"—how fitting since "fine art" is a recent development within Jewish culture. We would be doing this not only for the Jewish community but for the culturally diverse larger community. We hoped these themes would be illuminated for and find resonance in all communities and generations.

It became evident that *Jewish Artists: On the Edge* was attempting to connect the work of contemporary Jewish artists with the ongoing dialogue surrounding the relationship between art, identity and community. In order to accomplish this we needed artists of varied viewpoints, media, life experience, age and heritage. We hoped to find investigations of deeply felt issues regarding displacement, marginalization and assimilation on the one hand, and persistence, reclamation and re-articulation on the other, as well as themes we could hardly predict or foresee.

That this was something we had in common with Chicano, Native, Mestizo and Asian communities whose consciousness of identity is also constantly evolving, was an exciting revelation and led to a most unusual occurrence: the decision to re-think and clarify the mission of the Jewish Community Council of Northern New Mexico. The existing mission statement had been tentative in the area of cultural responsibility and so we added "...to provide cultural programs that reach out to the larger community, focusing on common causes that bind all

peoples and communities together...". *Jewish Artists: On the Edge* began to change the shape of the entity that conceived it!

Invitations were extended to 125 local, regional, national and international artists of high recognition and those aspiring towards recognition. This was the Steering Committee's "compromise" that became an unusual goal "to bring emerging artists into the center of the cultural arena by coming together with established artists - for a common cause." Rarely seen and unfortunately difficult to accomplish in the visual arts, this is common practice in realms of music, theatre and film.

To amplify the impact of this exhibition and expand its accessibility public discussions/dialogues with the artists, curators and critics seemed essential. Donald Kuspit was enthusiastic about the project and interested in the goals and motivations for it which led to my discussions with Louis Grachos, Director of SITE Santa Fe, facilitated by Madelin Coit. He became intrigued and offered a pre-exhibition dialogue between Ori Zarah Soltes and Donald Kuspit as part of SITE's *Art & Culture* Series. Artists and curators came from all parts of this country to participate in a panel discussion the day of the public opening, funded by the New Mexico Endowment for the Humanities. And this catalog, which also amplifies the impact of *Jewish Artists: On the Edge* has received generous private support which is greatly appreciated.

<p style="text-align:center">* * * * *</p>

I acknowledge and thank all the members of the Steering Committee who participated at various times: Ursula Balagura, Leslie Brodsky, Gail Rae-Davis, Rabbi Malka Drucker, Deborah

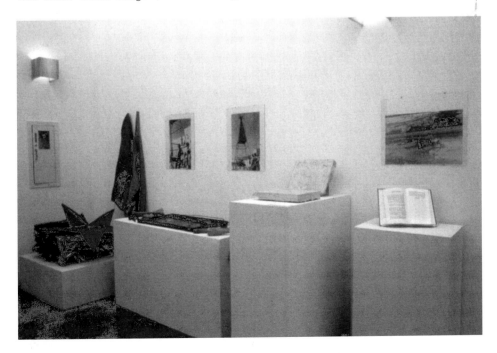

Finkelstein, Geraldine Fiskus, Karen Kolbert, Judy Moore-Kraichnan, Richard Lampert, Mary Leatherberry, A.J. Melnick, Stan Rosen and Samoa Wallach. Leah Kellogg, President of the JCCNNM whose dream this was, devoted many hours and much of her energy towards its success. I also thank those who appeared at the final stages to help make *Jewish Artists: On the Edge* happen at a crucial moment and in the best possible way: David Astilli, Mary & Jim Leatherberry, Trevor Lucero.

Thank you, Peter Burman and Deborah Finklestein, immediate past CO-presidents and Stan Rosen, current President of the JCCNNM. I hope you will build on the foundation that Leah Kellogg has created, and continue this new role of the JCCNNM in exploring and shaping Jewish cultural identity. *Edge* artist Judy Moore-Kraichnan is applauded for her beautifully designed invitation to the Santa Fe showing. Geraldine Fiskus, also a participating artist has devoted 2 years of her life, giving of herself wherever and whenever needed. *Jewish Artists: On the Edge* could not have attained its stature and success without her. May Stevens' encouragement and help in preparing this essay is also appreciated.

James Enyeart, Director of The Marion Center for Photographic Arts responded wholeheartedly with a commitment of space, followed by Rick Fisher, then Acting Chair of the Art Department at the College of Santa Fe.

Louis Grachos, Director of SITE Santa Fe displayed an uncommon flexibility, insight, integrity and generosity in hosting the pre-exhibition dialogue with Donald Kuspit and Ori Zarah Soltes on April 12, 2000, at SITE Santa Fe. This event placed *Jewish Artists: On the Edge* in the public eye. Marianne Dell, Public Relations Coordinator must be recognized for her professionalism and consideration. We are also grateful to the New Mexico Endowment for the Humanities for funding the panel discussion moderated by Ori Z Soltes, with Regine Basha, Madelin Coit, Dorit Cypis, Sam Erenberg, Ron Prokrasso and myself, J. Barry Zeiger, June 4, 2000 at The Marion Center for Photographic Arts, College of Santa Fe.

For their support and enthusiasm we thank Sylvia Herskowitz, Director and Reba Wulkan, Contemporary Exhibitions Coordinator at the Yeshiva University Museum in New York City for hosting the exhibition from November 2001 through February 2002.

Finally, Ori Zarah Soltes as Curator provided invaluable support in fundraising and image-raising for the project, even as his vision completed the process of conceptual broadening that had begun as the exhibit moved from its starting point. We applaud his expertise and discrimination in creating a complex and provocative exhibition that sheds light on contemporary issues of Jewish identity and at the same time has found resonance within all communities.

IS THE CONCEPT OF JEWISH-AMERICAN ART VIABLE?

Donald Kuspit

This is a postmodern talk(1), in that it consists of quotations about the Jewish experience and the American experience, with some commentary along the way. I will conclude with a brief analysis of the abstract art of Mark Rothko and Barnett Newman, two Jewish-American artists. Their art appears to contradict my thesis, namely, that the notion of Jewish-American art is a contradiction in terms. For I hope that the quotations will show that what it means to be Jewish in spirit cannot be reconciled with what it means to be American in spirit. However, the art of Rothko and Newman only appears to contradict my thesis. There are aspects of it that can be interpreted as Jewish-American, although I will argue that it is ultimately more Jewish than American, indeed, fundamentally Jewish and superficially American. I hope to convince you that their abstract art is quintessentially Jewish—a basic statement of Jewish principle, all the more uncompromising because it operates in a rigorously aesthetic way, without the distraction of Jewish social iconography, with its readymade answer to the question of what makes an art Jewish.

If I can convince you that the formal structure of the paintings of Rothko and Newman is subliminally Jewish, and in fact conveys in a kind of aesthetic nutshell the basic idea that the Jew represents, then I will have made my point at the deepest level. I will even insist that the art of Rothko and Newman, which is concerned with the aesthetic core of art, uses it to convey the core of Jewishness, that is, it mediates Jewish meaning through the aesthetic immediatism that is inseparable from pure art, suggesting that quintessentializing modernist aesthetics is quintessentially Jewish in spirit, however unwittingly ...

The Judengasse signified more than Jewish isolation...It also signified Jewish autonomy.

— **Howard Morley Sacher**,
The Course of Modern Jewish History

...several of the French philosophes believed that rational consistency required them to regard the Jews as an obscurantist people, superstitious, backward, perhaps even less enlightened

than their Catholic peasantry. Baron d'Holbach, in his essay, "The Spirit of Judaism," insisted that the Jewish religion was permeated with avarice and self-interest; while Diderot, in an article written from the Encyclopédie, described the Jews as a nation of bigoted obscurantists. Even the mighty Voltaire, the mordant wit who laid bare the foibles of the ancient régime more trenchantly and ruthlessly than any other writer of the eighteenth century, so detested the Jews as relics of primitive Semitism that he felt compelled to observe: "You will find in them only an ignorant and barbarous people who have long exercised the most sordid avarice and detestable superstition, and an insurmountable hate for all peoples who have tolerated and enriched them." For the Jews, after all, were pietists, and the philosophes were rationalists; the Jews were clannish, and the philosophes were cosmopolitan. Conversely, the philosophes were anti-Christian, and Christianity had sprung from Judaism.

— **Howard Morley Sacher**,
The Course of Modern Jewish History

Secretly, I thought the synagogue a mean place, and went only because I was expected to. Whenever I crossed the splinted and creaking porch into the stale air of snuff, of old men and old books, and saw the dusty gilt brocade on the prayer shawls, I felt I was being pulled into some mysterious and ancient clan that claimed me as its own simply because I had been born a block away....

— **Alfred Kazin**,
A Walker in the City

The melting-pot concept of American life was given further, and perhaps unwitting, encouragement by the German Jews who established Young Men's Hebrew Associations and Educational Alliances. They were resolved to help Americanize and humanize the immigrant groups. But the children of the newcomers needed little further encouragement to shed their immigrant heritage; they were aware that this legacy brought with it not merely the stigma of foreignness, but also the stigma of membership in an unpopular race. "My dominant childhood memory," recalls the novelist Meyer Levin, in his autobiographical In Search, "is of fear and shame of being a Jew." The most common means of expressing this

shame, according to the psychologist Kurt Lewin, was the avoidance of the company of other Jews. Another technique was to "let the children decide their religious loyalty for themselves." Yet another variety of self-consciousness, perhaps even of self-hatred, was demonstrated by Jewish philanthropists who contributed exclusively to non-Jewish causes. Less pathological, but most typical of all, was the swift adoption of non-Jewish names. During the 1920's and early 1930's Weinstein became Winston, Schoenberg became Belmont, Ginsberg became Gaines, Horwitz became Orwitt, and Cohen became Priest.

In a climate where group affiliation, religious education, and synagogue attendance were entirely voluntary matters, Orthodox Jews floundered hopelessly in search of solid cultural and religious expression. The impact of American secular life, the preoccupation with economic advancement, the opportunities offered by an attractive and friendly non-Jewish civilization, made it progressively inconvenient to maintain intact the full spectrum of Jewish traditions and observances.

— **Howard Morley Sachar**,
The Course of Modern Jewish History

What Jewish thinkers at the turn of the century had viewed as the badly distorted occupational structure of Diaspora Jewry (a working class confined to light industries, almost no farmers, an insufficiency of "productive labor," a disproportionate concentration in petty trade, etc.) turned out to be much more attuned to the occupational structure of the industrial or postindustrial countries. This was due partly to changes in the Jewish occupational structure itself, but mostly to rapid advances in these countries from labor-intensive to labor-saving production, from small-scale farming to large-scale agricultural industries, and from a manual labor force in primary production to one increasingly assigned to service, distribution, managerial, and intellectual or semi-intellectual tasks. By the middle of the century it no longer seemed so "abnormal" that few Jews were farmers or that they crowded the professions. And those Jewish political and cultural movements which had rested their expectations on the survival of a strong Jewish proletariat—movements such as Labor Zionism, socialism, and even segments of Yiddishism—found that their "social base" was approaching dissolution.

— **Irving Howe**,
World of Our Fathers

Transported suddenly into unfamiliar suburbs, the second- and third-generation Jews — some of them children and grandchildren of those immigrants who had been left behind in poverty—began to look for new ways to live. From the very start, their experience was marked by a strain of self-consciousness. They were reaching toward ease and comfort, while wanting also to retain fragments of their Jewish past. They were eager to appropriate the amenities their education had taught them to value, while hoping to shake off parochial stigmas and embrace a new largesse of spirit and style. They moved far enough into the pleasures of assimilation almost to feel ready for the pleasures of nostalgia. But since they were, after all, Jews, many of them seem to have had some awareness of the oddity or the humor of their condition: they who had grown up in streets full of immigrant noises were now buying private homes with plots of grass, lawn mowers, weed killers, and station wagons. And as they moved into the suburbs step by ambitious step, their journey was studied and overstudied by sociologists, psychiatrists, novelists, and journalists, themselves often Jewish, and all intent upon squeezing out solemn conclusions or easy ridicule. The one thing that could be said with any assurance about this journey to the suburbs is that it was seldom begun or completed with much ease.

— **Irving Howe**,
World of Our Fathers

This desire for "a normal life" climaxed the experience of centuries. It was a wish to break out of a humiliating passivity, and, by joining ranks with other peoples in a world of order and rationality, to assume an active historical role....But it was a sign of a shared difficulty, perhaps of an "inherent" Jewish difficulty, that almost every strand of Jewish opinion acknowledged that the Jews could not gain "a normal life" in any normal way: not through personal striving, not through individual sobriety or collective efforts, not through any of the paths available to other peoples. "A normal life" for a people whose whole history, by the standards of the external world, had been strikingly abnormal, could therefore be regarded as reachable only through extraordinary measures: through programs, upheavals, shattering transformations of a political-ethical character. True, there were still religious Jews who believed that so long as the Jews remained in galut "abnormal life" was appropriate, that is, normal; they looked with disapproval upon any attempt "to press for the End," let alone attain messianic goals through mundane action; they placed their faith in God and were prepared to wait. But waiting was

precisely what the most energetic young Jews proposed no longer to do. Did it then occur to the Jewish ideologues that achieving "a normal life" through the kinds of "abnormal" exertions they felt constrained to advocate might in turn lead to new varieties of Jewish "abnormality?"...Or did the Jewish ideologues recognize that the idea of "a normal life" may have been, for Jews, unacceptable and even unrealistic?...And then, of course, there was a possibility which few of the Jewish ideologues could really take into public account, since it seemed likely to induce the very resignation they were pledged to resist—the possibility that for Jews to remain Jews it might be better not to worry about anything so improbable as "a normal life," since it would have to be purchased at too high a cost in self-laceration and self-denial. Perhaps the essence of being a Jew meant to live forever in a state of expectation for that which would not come. America...imposed its own decision. Once past initial barriers, the Jews were allowed an entry into social and economic life on terms more favorable than any they had dreamed of. But America exacted a price. Not that it "demanded" that the immigrant Jews repudiate their past, their religion, or their culture; nor that it "insisted" they give up the marks of their spiritual distinctiveness. American society, by its very nature, simply made it all but impossible for the culture of Yiddish to survive. It set for the East European Jews a trap or lure of the most pleasant kind. It allowed the Jews a life far more "normal" than anything their most visionary programs had foreseen, and all that it asked—it did not even ask, it merely rendered easy and persuasive—was that the Jews surrender their collective self. This surrender did not occur dramatically, at a moment of high tension. It took place gradually, almost imperceptibly, and with benefits so large and tangible that it would long remain a question for legitimate debate whether Jews should have tried to resist the process of absorption. That they could have succeeded, hardly anyone supposed. It part, they did resist. They chose to reject a complete self-obliteration, the shameful fate of dissolving into anonymity. The "end of the Jewish people" which George Friedman had foreseen or feared in his striking book did not come, nor is it likely to come in the near future. Jews in America would remain Jews; their institutions would survive, flourish, and multiply; their religion would be kept alive by a phalanx of sentinels, and it could be chosen by anyone, Jewish or not, who was drawn to its promise. But very little of what held the immigrant Jews together—the fabric of their ways, the bond of common tradition, the sharing of language—was able to survive much beyond a century.

— **Irving Howe**,
World of Our Fathers

The New World, once its incoming inhabitants had found their roots, captured their imagination. In its vastness, in its ecological variety, in its range of climates and physiographic profiles, in both its teeming wildlife and in the hoarded treasure of food plants and trees, the New World was a land of promise, indeed a land of many promises for both body and mind. Here was a natural abundance which promised to lift the ancient curse of slavery and poverty, even before the machine lightened the burden of purely physical toil. The coastal waters teemed with fish, clams, oysters; and game was so plentiful that in the frontier settlements domestic beef and pork sold at a premium. Those who were at home in the wilderness, like Audubon, never lacked food, despite mortgages and debts. The belief that a better society would be possible in the New World stirred many a company of immigrants, from the Jesuits of Paraguay to the Pilgrims of Massachusetts and the later Hutterites in Iowa. Thus almost until the end of the nineteenth century the secret name of the New World was Utopia.

— **Lewis Mumford**,
The Pentagon of Power,
The Myth of the Machine

The Nazi plan for the liquidation of the Jews proceeded in stages. At the outbreak of the war in September 1939, it called for deportation en masse. Thousands of Jewish families were rounded up and dumped at ports and frontiers; other thousands were put aboard German ships with bogus Latin-American visas or with British permits for Palestine; while others were left to roam the high seas for months on end. For a while the Nazis toyed with the idea of a mass deportation of Jews to Madagascar. But systematic mass murder was not yet projected as a solution to the Jewish problem. The beginnings of change were first noticeable in March 1941, when plans were afoot for the invasion of Russia. Rumors began to circulate through the Reich Main Security Office that the Führer had entrusted Reinhard Heydrich with the preparation of a Final Solution of the Jewish question (the extermination of European Jewry was never referred to in any other way). French and Belgium Jews were suddenly denied permission to emigrate from German-occupied territory. After the opening of the war with Russia, Goering ordered Heydrich, on July 30, 1941, to "take all preparatory measures...required for the final solution of the Jewish question in the European territories under German influence." And finally Heydrich himself revealed the Final

Solution to his top staff members when he convened the notorious conference of January 20, 1942, in the office of the International Criminal Police Commission in Berlin, "Am Grossen Wannsee No. 56-8." Fifteen people were present, including SS and Gestapo heads of all occupied territories. Heydrich explained that the war with Russia had made unfeasible the plan of deporting all Jews to Madagascar. The only alternative, he pointed out, was exter-mination. Those Jews who survived the physical hardships the Nazis had in store for them "must be given treatment accordingly, for these people, representing a natural selection, are to be regarded as the germ-cell of a new Jewish development, should they be allowed to go free." With these orders the fate of European Jewry was sealed.

...Although two thirds of Russian Jewry managed to escape into the interior with the Red Army, it is probable that fully 1,000,000 Jews were trapped in the German zone of occupation. It was not difficult to dispose of the hundreds of thousands of Jews who were con-centrated in the large cities of White Russia and the Ukraine. In Minsk alone some 75,000 Jews fell into German hands and were systematically slaughtered. In Kiev 33,000 people were murdered within two days on September 29 and 30, 1941, in the single largest mas-sacre of the war; they were shot and buried in the huge Babi Yar ravine, where, a few months later, their gas-bloated bodies literally exploded out of the earth. In October 1941, 30,000 Jews of Dnepropetrovsk were machine-gunned to death and buried in the antitank ditches outside the city, and there were further mass executions at the Jewish cemetery of Dnepropetrovsk at intervals until March 1942. Another 20,000 Jews were slaughtered at Poltava, 2000 at Kharkov, many of them buried alive in their huts, 35,000 at Odessa, 10,000 in Simferopol. In Latvia some 170,000 Jews were killed, and in Lithuania no less than 250,000. By 1943 the SS had largely completed its assignment in occupied Russia. Fully 800,000 Jews had been executed by that time. Not even the Jews of Poland were destroyed with such relentless speed and organized fury.

— **Howard Morley Sachar**,
The Course of Modern Jewish History

Is there a Jewish art? They build a Jewish Museum, then ask, Is there a Jewish art? Jews! As to the question itself, there is a Gentile answer and a Jewish answer. The Gentile answer

is: Yes, there is a Jewish art, and No, there is no Jewish art. The Jewish answer is: What do you mean by Jewish art? Needless to say, the Gentile answer, either way, is anti-Semitic.

— **Harold Rosenberg**,
"Is There A Jewish Art?"
in *Discovering the Present*

I repeat, Sartre abhors anti-Semitism. But accept his premise of the Jewish mind with its incapacity for art and you have the raw material out of which anti-Semitism has been formed. From the image of the man limited to abstract ideas, it is but a step to that of the man dedicated to cash, since the chief abstraction in the modern world is, of course, money. The explanation of why the Jews don't have art and the conception that they are devoted to money fit together and provide a description of a kind of unlikable people. In short, whether one says that the Jews have art (but off the beaten track) or that the Jews have no art, one tends to wind up with notions not very flattering to Jews.

As to the facts of the matter, they are not much help. In the last fifty years, Jews have become quite prominent in painting and sculpture, and if Jews produce art, it would seem that there must be Jewish art. On the other hand, it is generally agreed that there is no such thing as a Jewish style in art. The upshot is that while Jews produce art, they don't produce Jewish art.

— **Harold Rosenberg**,
"Is There A Jewish Art?"

I have...my own fanciful "modernist" theory of why the Old Testament excluded carvings and paintings. It is that in a world of miracles, the fabrications of the human hand are a distraction. In the landscape of the Old Testament, anything (a garment, a slingshot, the jawbone of an ass) or anybody (a shepherd boy, a concubine) may start to glisten with meaning and become memorable. (One finds a trace of something similar in Whitman: instead of constructing images, he catalogues objects of the American scene, the idea being that art is anything that appears in the aura of wonderful.) Thus, the Old Testament is filled with a peculiar kind of "art," which we have begun to appreciate in this century: Joseph's coat, Balaam's ass, the burning bush, Aaron's rod. If there were a Jewish museum with

those items in it, would anyone miss madonnas? I am not suggesting that the ancient Hebrews were the inventors of Surrealism. But the idea that if you inhabit a sacred world you find art rather than make it, is clearly present in the Old Testament. When the mind of the people is loaded with magical objects and events, which unfortunately cannot be assembled physically, what is there for artists to do but make cups for ceremonial drinking and ornaments for the Torah?

— **Harold Rosenberg**,
"Is There A Jewish Art?"

The most serious theme in Jewish life is the problem of identity. The Jew, of course, has no monopoly on the problem. But the Jewish artist has felt it in an especially deep and immediate way. It has been a tremendously passionate concern of his thought. It's not a Jewish problem; it is a situation of the twentieth century, a century of displaced persons, of people moving from one class to another, from one national context into another.

In the chaos of the twentieth century, the metaphysical theme of identity has entered into art, and most strongly since the war. It is from this point that the activity of Jewish artists has risen to a new level. Instead of continuing in the masquerade of conforming to the model of the American painter by acquiring the mannerisms of European art, American Jewish artists, together with artists of other immigrant backgrounds—Dutchmen, Armenians, Italians, Greeks—began to assert their individual relation to art in an independent and personal way. Artists such as Rothko, Newman, Gottlieb, Nevelson, Guston, Lassaw, Rivers, Steinberg, and many others helped to inaugurate a genuine American art by creating as individuals.

This work, inspired by the will to identify, has constituted a new art by Jews which, though not a Jewish art, is a profound Jewish expression, at the same time that it is loaded with meaning for all people of this era. To be engaged with the aesthetics of self has liberated the Jew as artist by eliminating his need to ask himself whether a Jewish art exists or can exist.

— **Harold Rosenberg**,
"Is There A Jewish Art?"

What ethnic identity politics had in common with fin-de-siècle ethnic nationalism was the insistence that one's group identity consisted in some existential, supposedly primordial, unchangeable and therefore permanent personal characteristic shared with other members of the group, and with no one else. Exclusiveness was all the more essential to it, since the actual differences which marked human communities off from each other were attenuated. Young American Jews searched for their "roots" when the things which stamped them indelibly as Jews were no longer effective markers of Jewry; not least the segregation and discrimination of the years before the Second World War.

— **Eric Hobsbawm**,
The Age of Extremes,
A History of the World, 1914-1991

The Augustinian doctrine that 'the Jew is the slave of the Christian' was soon embedded in canon law and confirmed by the Third Lateran Council (1179). Even the great medieval philosopher St Thomas Acquinas (1125-74) affirmed the legitimacy of holding the Jews in 'perpetual servitude' for their crimes, while urging that they not be deprived of those things necessary for sustaining life. At the beginning of the thirteenth century, Pope Innocent III (1198-1216) was even more emphatic about the need for 'the blasphemers of the Christian name' to be 'forced into the servitude of which they made themselves deserving when they raised their sacrilegious hands against Him who had come to confer true liberty upon them, thus calling down His blood upon themselves and their children'. Innocent III also believed, like St Augustine before him, that the Jews must be preserved as 'wanderers' upon the earth until they acknowledged their crime and called on the name of Jesus Christ as Lord and Savior.

— **Robert S. Wistrich**,
Antisemitism: The Longest Hatred

By compelling the Jews to leave the Reich as paupers, the Nazis buttressed the legend of the Wandering Jew....

— **Howard Morley Sachar**,
The Course of Modern Jewish History

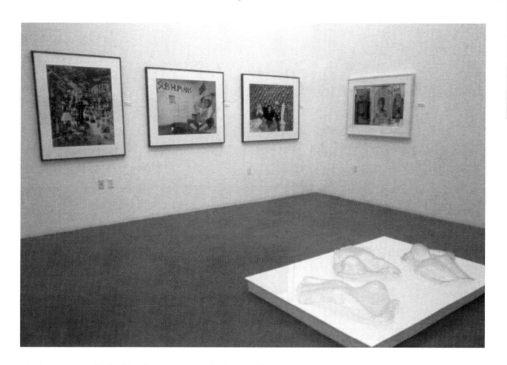

Having reported all this—having reminded you of what it is to be a Jew socially and emotion-ally (something American Jews tend to forget)—the question remains: what does Jewishness symbolize? The Jew must be a powerful symbol—the symbol of an important idea—for anti-Semitism to be so relentless, for the wish to exterminate the Jew to recur so regularly in all kinds of societies. Its virulence is all the more peculiar in that there are not that many Jews in the world. I want to suggest that hatred of the Jews has to do with hatred of the law, which the Jews represent. It is steadfast Jewish devotion to the law that makes them seem superior, sets them apart, and makes them anathema, for the normal human tendency is to want to break the law, and return to a state of lawlessness. It is their constant—some would say carp-ing—concern with the order and boundaries established by law that has made the Jews sacred, an Eternal People as Israel Kasovich calls them, and made them hateful, for such idealization of the law, leading to rigid adherence to it, and a certain holier-than-thou arrogance, goes against the grain of human weakness, the inclination to give in to lawless, unbounded impulse.

Kasovich quotes the poet and philosopher Judah Halevy: "God chose to give the Law to the Jews because they possessed the proper spiritual qualities." Kasovich also quotes the Talmud: "God offered the Torah to every nation and each rejected it, until he came to Israel who accepted it." Thus the Jews are the exception to the lawless rule, so that to annihilate the Jews is to deny the law. Kasovich also points out "that the Hebrew word *emunah*, which is generally translated as 'faith,' means more than mere belief. *Emunah* means firmness, consci-entiousness, truthfulness, trust, and strong conviction. The Christian religion, for example, enjoins men only to believe. If you believe, your sins will be forgiven and you will be justified. The Torah, on the other hand, contains no commandment enjoining us to believe.

The Torah merely says, 'Thou shalt know thy God'." This means: thou shalt know the law, even if it does not benefit one personally. It means: thou shalt obey the law, even if obedience does not validate your life.

Now the abstract art of Rothko and Newman is anti-suburban—irreconcilable with the suburban ease and comfort that secular America strives for—because it is Jewish, that is, celebrates the law. Like biblical prophets, Rothko and Newman call for backsliding Jews—Jews living the good suburban life, Jews who have become American pagans, satisfying every material impulse, even as they give lipservice to their religion without understanding its spirit—to return to the law, to the one true God who represents the law, who has given the Jews the unique gift of the law and made them his and its representative on earth. Their gadfly abstract art calls for the Jews to forsake the egalitarian utopia of limitless felicity America claims to be, and return to the law, which does not treat everyone the same way—the law-abiding and law-breakers are accorded different treatment—and which realizes that limitless felicity is a personally grandiose and socially dangerous illusion. The law in fact is established in lieu of utopia, and in recognition of the fact that it is an unrealistic dream. It is because utopian dreams will invariably be frustrated, and every attempt to realize them lead to social chaos and self-destruction, that the law is established.

So what is the law? Janine Chasseguet-Smirgel writes, in an essay on "The Secret Ceremony in Shakespeare": "As we know, the Bible insists on the principle of division and separation, as opposed to nondifferentiation and chaos....Whoever disobeys the law of differentiation sets himself up in the place of God and becomes a demiurge....There is an ever-present temptation to undermine the natural ordering of the universe....It is a longing that

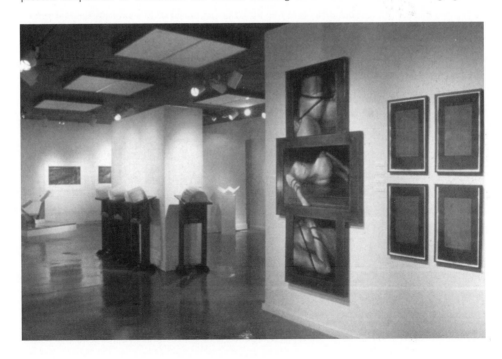

exists in both polytheistic and monotheistic religions, and is probably a constant of the human mind (the 'perverse' core being universal in this case, whereas the perverse organization is not)." The Jews symbolize the law of differentiation that is irreconcilable with the perverse core of human beings—the wish to break the law, to turn the world upside down, to obscure natural divisions and realistic separation in a demiurgic frenzy tempting one with utopian freedom (Chasseguet-Smirgel notes that the "'world-inverted, world perverted' formula" was coined by the fervent Calvinist, Agrippa d'Aubigné [1552-1630])—which is why the Jews must be destroyed, and why they seem superhuman and uncanny, and as such peculiarly perverse themselves.

Indeed, perverse logic declares that the Jews ought to be killed, for it was the Jews who established the law that human beings should not kill each other—as Chasseguet-Smirgel notes, the substitution of a ram for Isaac in the Old Testament marks this moment—and the most fundamental impulse is to kill your neighbor before he kills you. Once the Jews have been killed, one can kill anyone, and feel no remorse—no sense that one has broken the law. One can of course also be killed by someone with no remorse. That is, the way to the war of all against all is re-opened, setting civil society back to pre-law days. Christians continue to practice murder—human sacrifice—in symbolic form, which is why anti-Semitism seems fundamental to it. As Gunnar Heinsohn argues, in anti-Semitism "the guilt Christians experience when the son of God is sacrificed and devoured...is projected onto Jews who have renounced all human sacrifice," giving Christians the license to literally kill Jews, with no remorse at the fact that they have broken a fundamental law of civilization, indeed, the law that permits it to get started. (Consubstantiating Christians believe that they actually devour the flesh of Christ when they take communion, suggesting the replacement of symbolic thought by "concrete thought and the act of murder to which concrete thought leads," as Chasseguet-Smirgel says.)

Now in Rothko the principle of division and separation emerges from the unprincipled ecstasy of color equality, emblematic of democratic egalitarianism. There is an American tendency to ecstatic egalitarian merger—losing the self in the collective color field—even as the Jewish law of differentiation is in the process of being established, however uncertainly. Newman seems to overcome this awkward simultaneity: his so-called "zip" represents the law of differentiation, which allows autonomous selfhood—the zip also symbolizes it—to appear spontaneously, that is, miraculously, like a burning bush, in the undifferentiated field, which for all its ecstatic color is a desert. The zip is the Apollonian moment of lawful division—symbolized by the division of the Red Sea by God, which is hypnotically reiterated and hallucinated in the multiple separations of the red field in Newman's *Vir Heroicus Sublimis*, 1950-51—in the midst of Dionysian lawlessness. The zip signals: to be one separate being and one separate being only, that is, it signals monotheism and being uniquely one's self, which monotheism symbolizes. (When asked who he is, God answers: "I am who I am.") For Newman, "onement," as he calls it, represents the decisive moment of individuation: the refusal to be

absorbed by—dissolved in—the undifferentiated field of existence. It is the moment of self-containment and self-enframement in the uncontainable, unframeable field of life—the moment of becoming a particular being in the general field of being. One is spontaneously precipitated out of the field by an act of self-differentiation. The sublime is the enemy of the self, for the sublime is undifferentiated and lawless, that is, it lacks the law that can establish it as a habitable space, that is, divide it so that it is human scale and thus manageable.

Because the Jew stands for the law of differentiation that makes one one with oneself and different from all the others, the Jew stands in lonely, isolated opposition to the amorphous egalitarian utopia of limitless American plenitude, which is premised on undifferentiated selfhood—the collective sense of self which is an unwitting acknowledgement of "selflessness." In Rothko we witness the separation of planes from one another, and the establishment of a hierarchy of colors, which maintain their differentiation however much they tend to merge. Newman articulates the basic moment of creation: the unexpected moment when an egalitarian (uniform) surface, American-ecstatic in principle—a melting pot in whose red hot heat all colors dissolve, losing their difference—is divided by a line emblematic of the integrated person, at last identical with himself, however attenuated (even more extremely than Giacometti's figures) because of his isolation and ostracization, that is, separation from the rest of humanity. This figure, reduced to a strong line in the void, is the Jew. Newman shows us that the Jewish law of differentiation is fundamental, while Rothko takes it for granted and builds on it, creating new divisions and separations.

Referring to America, Henry Wadsworth Longfellow famously wrote:

Humanity with all its fears,
With all its hope of future years,
Is hanging breathless on thy fate.

I have tried to show that these lines would make more sense if they referred to the Jews, who represent the principle of civilization—the lawfulness which gives civilization half a chance—rather than to America, which is probably one more passing society, sometimes law-abiding, sometimes not.

1. This essay is an abbreviated version of the talk given in April at Site Santa Fe.

Bibliography:

Janine Chasseguet-Smirgel, "The Secret Ceremony in Shakespeare," Journal of Clinical Psychoanalysis, 8/3 (Summer 1999).

Eric Hobsbawm, *The Age of Extremes: A History of the World, 1914-1991*. New York: Vintage, 1996.

Irving Howe, *World of Our Fathers*. New York: Simon and Schuster, 1976.

Israel Kasovich, *Eternal People*. New York: Hebrew Publishing Company, 1927.

Alfred Kazin, *A Walker in the City*. New York: Farrar, Straus and Giroux, 1951.

Lewis Mumford, *The Pentagon of Power, The Myth of the Machine*. New York: Harcourt Brace Jovanovich, 1964.

Harold Rosenberg, *Discovering the Present*. Chicago: University of Chicago Press, 1983.

Howard Morley Sachar, *The Course of Modern Jewish History*. New York: Delta, 1963.

Robert S. Wistrich, *Antisemitism: The Longest Hatred*. New York: Pantheon, 1991.

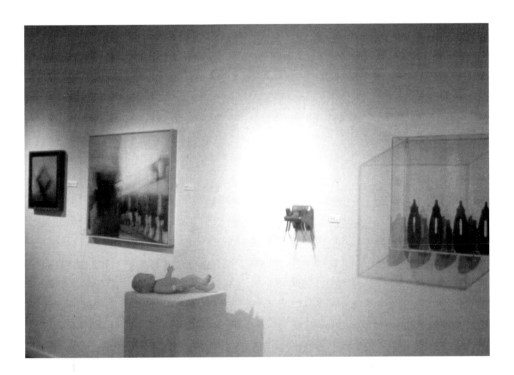

JEWISH ARTISTS: ON THE EDGE
Ori Z Soltes
Curator

I

LANGUAGE, CATEGORY, AND ART

Language, Category and Art
Language, Category and Art

anguage most obviously sets humans apart from other species. We are able to extend ourselves verbally as dogs and bears cannot. Words offer us an ability to explore, explain, communicate and understand. But they are also limited and limiting instruments: there are simply too many things for which words do not suffice. Both a sunset and the feeling it evokes defy capture in words—"exquisite" or "glorious" or "blood red" guide us toward it but don't allow us to arrive. Love, like other feelings, as many are the words to grasp it, remains beyond our verbal reach. There are also ideas beyond our experience, approachable only by approximation and analogy. "God" is perhaps the most significant of these, described through endless circumlocution across the millennia without our knowing how close or distant we are from verbally capturing what God *is*.

Adjectives are an essential subset of verbal self-expression, helping us to grasp more precisely what an entity is. Thus cars or trees or persons (or sunsets) are better grasped when we add: large, small, green, red, tall, short, male, female, wooden, stone, dull, shiny, new (young), old, exquisite, glorious—and so on. Adjectives function in part by being exclusionary. If it is large, it cannot be small; if it is female, it cannot be male; if it is black, it cannot be white. While this function makes them useful, at times the effect can be detrimental to our understanding— particularly when the adjective we use carries with it *preconceived* aspects of inclusion or exclusion or simply description which may be wrong, or at least not universally agreed-upon, without our realizing it.

In the realm of visual art, for example, distinguishing red from green and black from white is certainly useful. Applying certain adjectives—expressionist, impressionist, cubist, to name a few—can help us grasp some things about the style of a work of art and perhaps the intention of the artist, at least when the meaning of such terms is fairly well agreed upon. It may be useful but less essential to apply the adjective "French", "German", "Italian", or "American" to paintings or sculptures made at the dawn of the third Christian millennium, since the inter-

national connections within the art world and among artists mean that such terms often do little more than indicate the place where the art was made or the artist was born.

Other adjectives may prove altogether misleading because they incline us to limit the art and the artist to boxes. How useful are adjectives such as "woman," "African American," "Native American," "Hispanic," or "Jewish" when attached to the noun "artist"? They may well identify an essential aspect of what the artist is, but may also pre-limit our understanding of the artist's intentions and accomplishment.

We are irresistibly drawn to such designations, even when their effectiveness for enhancing our understanding should be suspect. We might call both Jacob Lawrence and Sam Gilliam "African American artists" or "Black artists" without recognizing how different their respective bodies of work are. Lawrence primarily focused on African Americans as his subjects in a distinctive almost poster-like social realist style, but what causes him to be recognized as a great artist is the quality of his vision and the human drama it encompasses, not the fact that the bridge to that greatness of vision and that drama happens to be mostly blacks rather than whites in an American, not a French or Chinese, context. Gilliam is an abstract artist for whom there is nothing overtly present in his work that identifies his race or draws inspiration from it. And should we find that particular inspiration in his work, we would not thereby have eliminated any number of other factors and features that cause us to admire it alongside Lawrence's very different work and alongside works by other artists who are not African American.

Madame Vigee-Lebrun is often referred to as the most accomplished female portraitist of the late 18th century, when both she and we would be better served if she were simply identified as one of the great portraitists of her era, without specifying her gender and thereby implying a limitation to her accomplishment. The same might be said of dozens of women artists of the past and even moreso, the present, who are automatically boxed into limiting preconception when we attach the adjective of gender to the noun "artist" to help classify their art and not merely to identify them.

Perhaps no group in the visual arts, in our era, is more haunted by the damning limits of adjectivalization than the Jews. "Jewish" when attached to "art" and "artist" all too often provokes a pre-packaged assumption regarding the intentions, shape and quality of the art and the artist. There is irony in this. For "Jewish" is a particularly uneasy-to-define adjective. Historically, we cannot be certain where it begins: Abraham is called a Hebrew, Moses an Israelite and Ezra a Judaean. The term "Jewish" itself is not cogently in use until the late first century CE, and it is not until that time that what we would recognize as Judaism—defined by the Bible Jews read, the prayers Jews utter, the Sabbath Jews observe, the life-cycle and annual festivals Jews celebrate—has begun to crystalize. More problematic still is the conceptual problem: what *is* Judaism? A religion, a culture, a nation, an ethnic group, a people, a body of customs and traditions?

Are we referring, when we use the phrase "Jewish art" to the identity of the artist? In which case are we referring to the birth or the convictions of the artist? Or are we referring to

the artwork itself? In which case do we mean subject, style, symbol, content, intent, purpose? To label something "Jewish art" or to label someone a "Jewish artist" should provoke questions of definition but rarely does. On the contrary, it is usually applied as if everyone *knows* what we mean by "Jewish"—and in that case, everyone agrees that the label defines a narrow limit. To call someone a Jewish artist or to call his/her work Jewish art seems, even more nefariously than with other kinds of identifying adjectives, to pre-box the artist or the artwork, evoking images of stylistic shlock or a limited vocabulary of overly obvious symbols.

The irony multiplies. Jewish artists, during the past hundred years or so, have played an inordinately large role—far out of proportion to their numbers in either the general population or the art-making population—in the shaping of modernism in all of its aspects. Take them away or push them into a limited classification as "Jewish artists" rather than simply calling them artists and we remove a substantial section of first-rate Euro-American artistic productivity since the middle third of the nineteenth century. Many of the most significant art historians and critics, as well as dealers and patrons during this era have also been Jews, and it is they, ironically enough, as much as non-Jewish writers and sellers and buyers who have shaped the label "Jewish" into an uncomfortably narrow one.

The consequence is two-fold. First, that many serious artists whose contribution has in part been informed by their Judaism—from the diverse social realism of Ben Shahn, Raphael Soyer and Jack Levine to the abstract expressionism of Marc Rothko, Barnett Newman and Adolph Gottlieb—have been torn from their Jewish moorings by the art world at large and the public that would enter that world. The stigma of being called a Jewish artist spreads to encompass any number of luminaries of the past two generations, from Morris Louis to Menashe Kadishman, to the detriment of a full grasp of their work. And second, that this condition persists for contemporary Jewish artists: the label "Jewish" is feared as one that, if attached to an artist or an artwork will shrink him/her/it into insignificance.

"JEWISHNESS" AND ART

To label something Jewish means to associate it with Jewishness. Yet it should not imply that that something—a painting, for instance—has no other associations. We are all compendia, in varying degrees, of a range of inputs, from our family and friends to our community and country, from what we read and what we hear to what we see around us on the streets, on television, in the theater and in the movies. We are informed by the individuals that we are and by the humanity of which we are part. To identify Jacob Lawrence or Sam Gilliam as African American or Vigee-Lebrun or Louise Nevelson as women – to refer to Betty Saar or Carrie May Weems as *both* black and female—might cause us to seek within the art they create the influence of their being black or female. To call Nevelson Jewish or to call Rothko Jewish might cause us to seek within their art the influence of being Jewish. But in no case should that mean that this is the only aspect of them to be sought or found – or that this aspect will be found easily if at all.

Marcia Reifman, a photographer from Madrid, New Mexico is represented in this exhibition by photos of family and friends in the Dead Sea, their faces plastered with the different-colored muds said to offer various healing qualities. One group, "Family", offers only the heads visible above the water, like a floating pile of variously-patterned stones. If we are struck first by the wonderfully eerie quality of the image, yet these "pebbles" remind us of those piled on a Jewish gravestone, left by visitors who have not forgotten the dead. The aesthetic impact is general, even as she observes of her work that *"my relationship between being Jewish and being an artist are linked no matter what my photography looks like. My experience growing up as a Jew was exclusion... I was told [by my parents] to hide the fact that I was Jewish... As I became older... I no longer wanted to deny this part of my being. So, how does this relate to my art? How could it not?... I have begun my 'coming out' as a Jew and as an artist...They are equally personal statements of who I am and my willingness to share this with the world."*

In short, her Jewishness offers a layer of, not a complete guide to her work. Nor by any means have all Jews had Reifman's experience of "exclusion". Conversely, not all have felt as strong a need or desire to perceive a link between Judaism and their art. Some have placed that link more obviously on the surface of their art than she has, others have hidden it, consciously or otherwise, even more deeply beneath the surface. **Lilly R. Fenichel**'s abstract *Waferboard Series*, of which "Double Take" is an example, is a varied exploration of purely

formal, abstract aesthetics, of the edge between two and three dimensions, between visual depth and depthlessness: *"ultimately these paintings are not about something, they are 'about themselves'."* Their abstract objectivity would not, per se, suggest Jewishness as an aspect of what hovers at their aesthetic edges. Yet *"the events following the Anschluss resulted in my having to acknowledge my Jewishness... My classmates [in Vienna] suddenly began to express overt anti-semitism... Jewishness is an integral and essential component of my life experience."* A viewer would be challenged to locate the Jewish aspect of Fenichel's life experience in her art without this quote—and without applying its significance to the aesthetic edge of being between realms defined by her work.

Conversely, **Benny Ferdman**'s tiny (3"x4") image of "The Queen", her crown surmounted by a six-pointed star, immediately suggests possibilities ranging from biblical commentary (the book of Esther - the only biblical book set in the diaspora) to the snide stereotype of the Jewish American Princess. But one may surely understand his words—*"...in many ways I see my role as an artist as one of forming and transforming collected and collective memory into personal history"*—as specifically Jewish or as universal. For memory is as much a defining human attribute as it is a Jewish obsession.

The relationship between Judaism and the art of Jewish artists won't fit into a box. Nor is this true only today. Pissarro, Modigliani, Soutine, Chagall, Pascin, Lipschitz, Shahn, Soyer, Rothko, Newman, Gottlieb, Louis, Levine, Nevelson and a host of other artists of the recent past (and in the case of Levine, still very much the present) - have been informed by an array of influences, including their Judaism. No two of these artists exhibit that influence to the same degree or in the same manner any more than even a single one of them has produced work that one would be inclined to view as informed *only* by Judaism. Each of them achieved the sort of stature such that we think of them simply as *artists*.

The manner in which some of them work overtly breaks the bounds of and upsets the categories of "Jewish" and "Christian" or "secular", as well as of "subjective" and "objective" or "narrative" and "purely formal". Consider, for instance, Marc Chagall's "White Crucifixion" (1938) and Barnett Newman's "The Name" (1950). In the first instance the most Christian of images greets our eye - and then our eye wanders around the canvas, and we note, detail by detail, elements that in the end turn the image into something significantly Jewish. From the synagogue on fire to figures fleeing with packs on their backs or Torah scrolls in their arms; from elders identifiable as Jewish by the phylactery boxes on the forehead of one of them, hovering in horror (where in a traditional *Crucifixion*, angels might be depicted weeping) to Christ wrapped in a loincloth that looks remarkably like a Jewish prayer shawl, a *tallit*, the painting speaks of the Jewish condition. The ladder leaning against the cross which, in a traditional Christian scene, would offer Nicodemus and/or St Joseph of Arimathea lovingly and carefully removing the body from the cross - turning the *Crucifixion* into a *Deposition*—is empty.

The sum offers a dark vision in spite of the abundance of bright pigments: this is not the Savior of humankind, but a suffering Jew for whom there is no redeemer and no salvation, par-

ticularly in the Christian world leading into the Holocaust. This pessimism is confirmed by the menorah at Christ's feet. It has only six candles. The redemptive seventh candle, the Sabbath-related candle essential to the menorah as a salvational image across Jewish visual history, is missing. The artist has altered the most traditional of Jewish symbols just as he has transformed the most traditional of Christian subjects into an elegy for Jesus as the paradigmatic suffering *Jew*.

Newman's image—an all-white triptych—doesn't lend itself, at first glance, to such an analysis. But the artist often accorded titles to his works which further accentuate the intent which would otherwise have been virtually invisible — and which might still remain invisible to a viewer unaware of word-specific Jewish issues. Thus when he named his all-white (ie all-color-absent) canvas *The Name*, he chose as a title the traditional Jewish circumlocution for "God", a word never spoken outside the context of prayer; the phrase "The Name" (*haShem*, in Hebrew) is substituted. The title tells those who understand that this painting of colorlessness—which, from a traditional color-equals-painting viewpoint, is a *non*-painting—can be seen as a *non*-portrait, a visual circumlocution of the unportrayable God.

One might say that Newman has solved the Jewish problem regarding the millennia-old purpose of art as serving religion by depicting Divinity. For he has appropriated one of the classic forms of Christian visual self-expression, the triptych, but replaced the image of the Crucified Christ or the Christ Child on the Madonna's lap, flanked by saints and other attendants, with what is simultaneously the absence of color and, particularly to the extent that the luminous quality suggests *light,* the *totality* of color. The God Who Cannot Be Represented is portrayed without being represented. Moreover the sense of absence which coincides with the sense of presence may also be seen as a comment on God's absence or presence during the Holocaust—an issue that engaged Newman in the late 1940s and early 1950s. The image also offers a post-Holocaust visual repairing of the world—*tikkun olam*—upon which issue Newman, together with Rothko and Gottlieb, spent a good deal of time reflecting. For the unified light-whiteness of the image holds the microcosm of its heroically-scaled, unframed canvas emphatically together, in an absolute, ordered structure.[2]

Nobody would limit Chagall or Newman to circumscription by the rubric "Jewish artist", in part because their work is admired whether or not one applies the specific interpretive instruments that I've just used to explore it. The same should be true of scores of more recent artists. They happen to be Jewish; that fact informs to a tiny degree or to a major degree the work they create, in ways that are obvious or barely noticeable without careful inquiry. They share in common the fact that their work is on the cutting edge of artistic productivity at the beginning of a new millennium. There is an extensive range of issues they address and they accomplish their inquiries by means of a wide variety of media and styles.

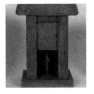

Nobody would limit contemporary artist **Tobi Kahn**, either. Indeed Kahn, recognized in a 1985 Guggenheim Museum exhibition as one of nine young artists representing "New Horizons in American Art", stands simultaneously on several borders that make limiting the

sense of his work an impossibility. On the one hand his paintings – landscape-like abstractions, which in their luminous spiritual quality evoke Marc Rothko and in their biomorphic qualities recall Arthur Dove and Georgia O'Keefe—are richly sculptural. On the other, he does Jewish ceremonial objects, albeit with a newness of style and method that recalls his paintings and sculptures. And as for his sculptures, whole groups of them—the "Shrines", in which carved pieces of wood, cast in bronze, are placed within architectural settings—suggest liturgical art without being liturgical art. He has been creating these for years, in all sizes; they simultaneously evoke Greco-Roman aedicula (temple-like grave markers, with the deceased shown in relief within the frame of the "temple"), Christian reliquaries and—not least of all—the *mishkan* itself in the Jewish tradition. Inspired by diverse art historical elements they in turn bridge them to each other and to abstract contemporary art. His Judaism and his art are subtly interwoven strands in one tapestry. More than this, all of his works have names, made up, (sometimes but not always of Hebrew elements) which evoke but don't quite land on recognizable subjects. Thus they demand thoughtful participation from the viewer to "read" them: *"Look and look again. Tranquility grows disturbing; tension gives way to serenity. The poetry of color, the severity of form, convey the seduction of memory, which alchemizes unconscious daily life into lyrical and awe-filled landscapes of the mind"*, he wrote in 1993.[3]

Archie Rand's work may be more obviously "Jewish", but not to fit into a box of Jewishness. It consistently expresses the emphatic conviction that art can be contemporary – even abstract – and bear overtly Jewish content. One of the consistent features of his work is text – the ultimate Jewish "tradition" — but invariably superimposed over visual elements that would be more likely otherwise to invoke chromaticist abstract expressionism. As both a painter and an art historian he is acutely conscious of the underlying spirituality of modernist greats like Cezanne, Picasso and Pollock and is wont to push the edge of interface between their work and more overt religious concerns – and then to do the same to his own work: as a Jew in the arts community and an artist in the Jewish community. From his overrunning the walls of the B'nai Yosef synagogue, in Brooklyn, (1974-77) with murals that in their totality recall the mid-3rd century synagogue at Dura Europus, to his 1994 series of paintings, *The Eighteen: Blessings at the Heart of Jewish Worship*, Rand consistently synthesizes the oldest of Jewish visual imagery with features customarily thought to eschew religious connection. After the B'nai Yosef murals, *"my fear of having my Jewishness crawl recognizably into my exhibition work was abating. It was replaced with teasing delves into what was for me daredevil Jewish iconography mixed up, uninvited, with my more traditional secular attempts"*, he commented in 1986.[4] Rothko and Pollock share conceptual space with Nachmanides. Moreover, his striding back and forth between cartoon-like elements and "fine art" elements, and his application of cartoon elements to the most serious of subjects – often exhaustive series focused on those subjects — wrily pushes the Warholian pop art message to the outer edge of its envelope.

Gallery

Gallery

GALLERY

"Art that is not necessarily in the center of a society often expresses more clearly the responses of artists to that society. There is depth and breadth to the work included in '...Edge' that made the time and effort to ensure its arrival at Yeshiva University Art Gallery worth while . "

Madelin Coit
Tesuque, New Mexico, 2001

Mel Alexenberg

Divine Retribution
(detail)

1998
mixed media
dimensions vary

Helene Aylon

Epilogue:
Alone with my Mother
(detail)

2000
mixed media
dimensions vary

Saul Balagura

Yeshua Preparing a
St. Peter's Fish

2000
Acrylic
48 x 30'

Rudolf Baranik

White Silince

1965-85
oil on canvas
64 x 86"

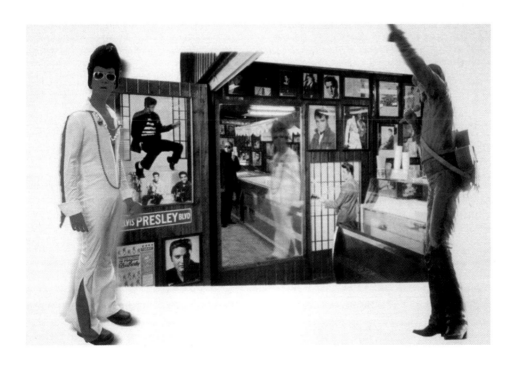

Arlene Becker

Elvis in Jerusalum

ca. 1997
Iris print on Arches paper
16 ¹/₂ x 29"

Alan Berliner

Gathering Stones
(detail)

2000
photo stills from
video installation
30 x 40" each

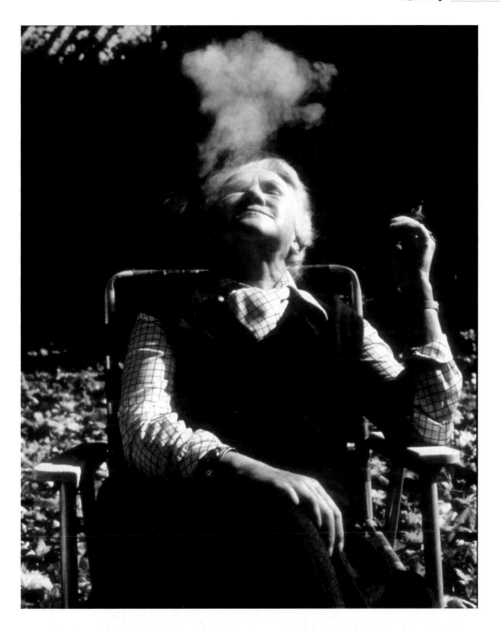

Gay Block

Baniecka
from *Rescuers of the Holocaust*

1996
photograph
24 x 20"

Judy Chicago

Study #3
for "Four Questions"
from *The Holocaust Project*

1992
4 Panels
9 1/2 x 42"

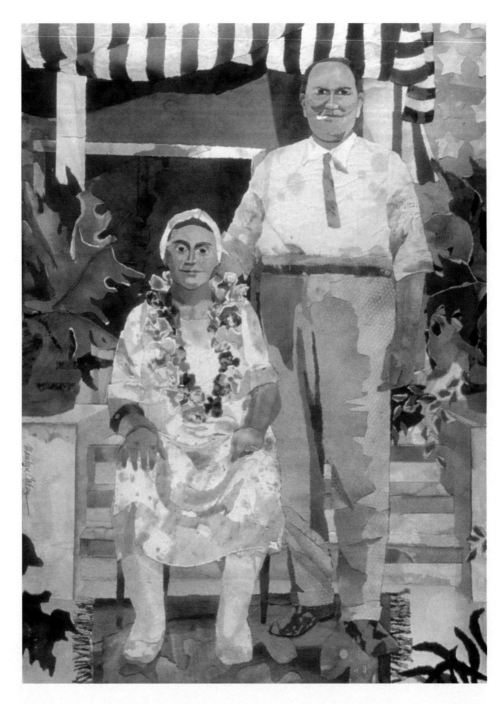

Marilyn Cohen

Aloha Gothic

1993
collage
42 x 30"

Madelin Coit

The Big Bamboo

1999
text and Venetian blind
48 x 20"

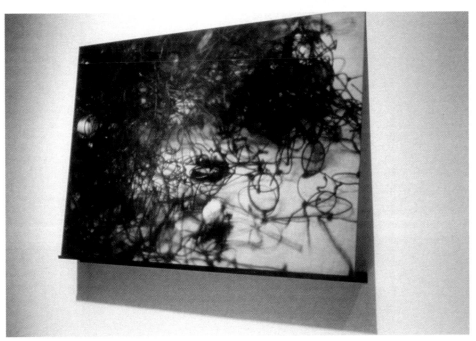

Dorit Cypis

Aesthetics: Eyeglasses

1997
Ilfochrome and
steel shelf
24 x 30 x 4"

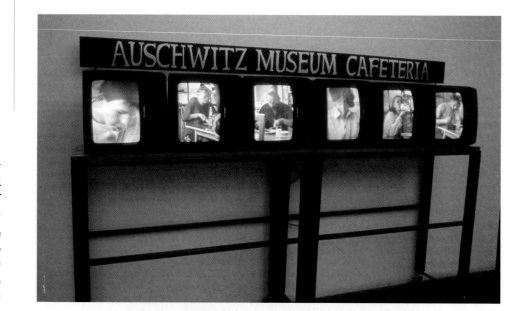

**July Dermansky
and
Georg
Steinbock**

*Auschwitz Museum
Cafeteria*
(Detail)

1999
video installation

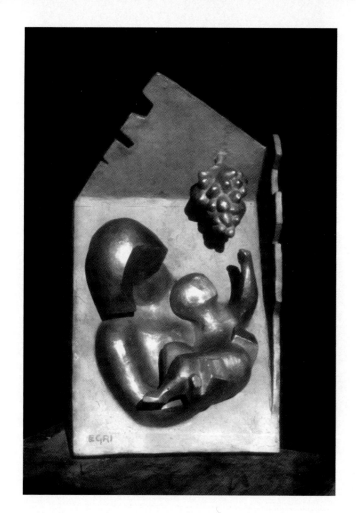

Ted Egri

Sukkot

ca. 1985
cast bronze
10 x 9 x 3"

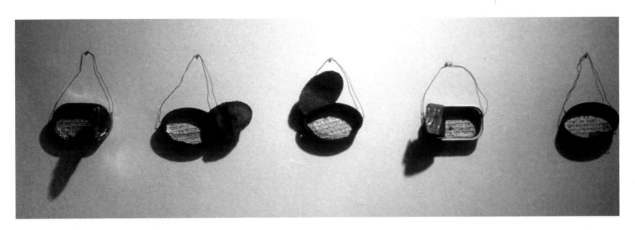

Avraham Eilat

Untitled

1994
sardine cans, wire, paper
each 4 x 5 x 1"

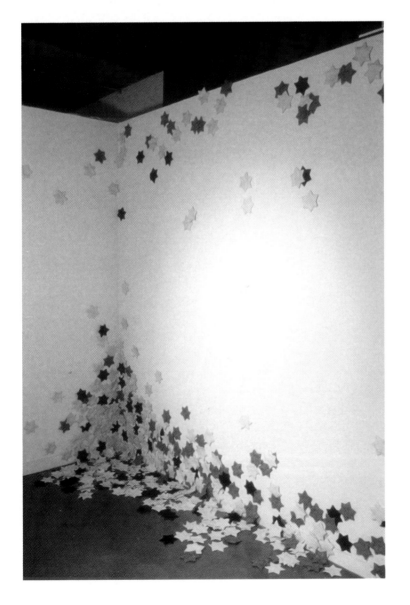

Sam Erenberg

Untitled

1999-2001
sewn felt installation
dimensions vary

43

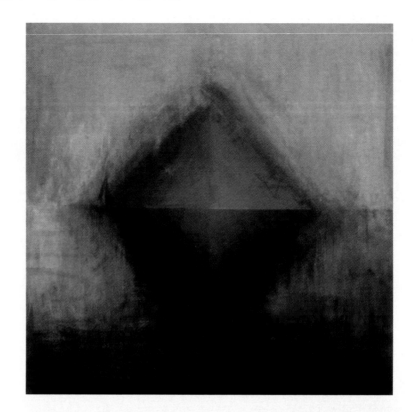

**Frank
Ettenberg**

*Study for a Manument to
European Jews*

1996
oil on linen

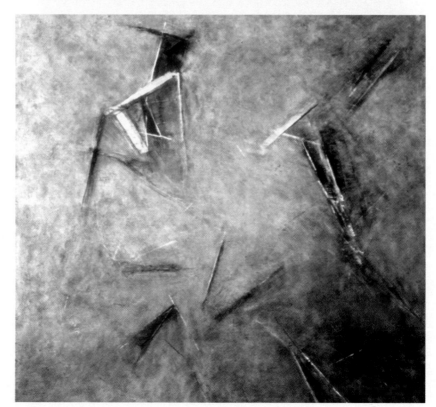

Lilly Fenichel

Emanation

1999
oil/wax on waferboard
48 x 48"

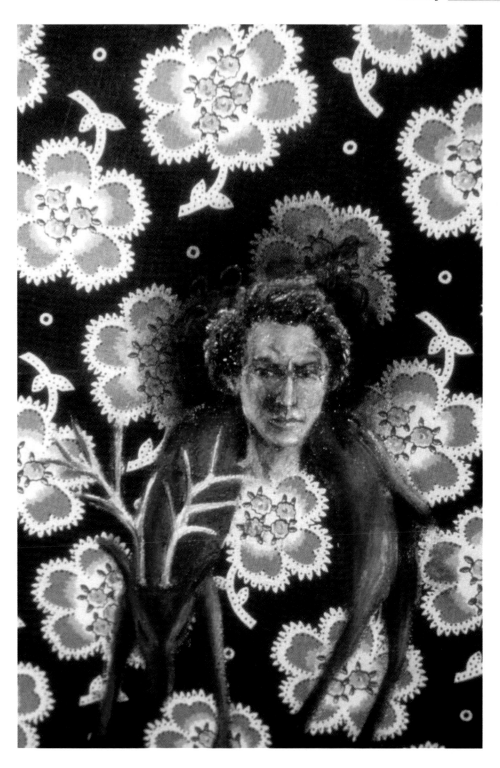

Benny Ferdman

Run Like a Deer

1998
oil, cloth
8 x 6"

Rose-Lynn Fisher

Doorway

1998
mixed miedia/
copperleaf/paper
15 x 34"

Rose-Lynn Fisher

Home/Homeland

1997
gelatin silver print
photograph
11 x 14"

**Geraldine
Fiskus**

Stelae 1: Cries
from the series
*Reinventing the Visual
Language of Jewish Stelae
in Eastern Europe*

1999
3 panels
2@ 46 x 32"
1@ 14 x 11"

Rachel Giladi

Sterile

1995
black paint on latex baby
bottles and gloves
10 x 16 x 3"

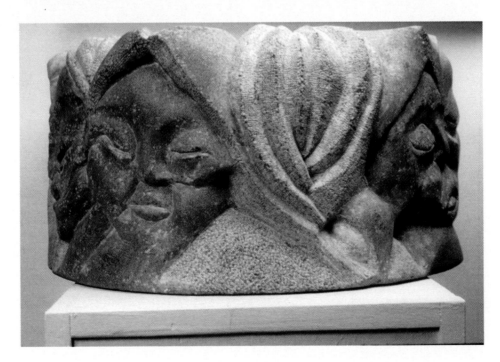

Sy Gresser

Tribal Faces (Menorah)

1996
carved steatite
24 x 24 x 20"

Cary Herz

The Five Commandments

1994
photograph
11 x 14"

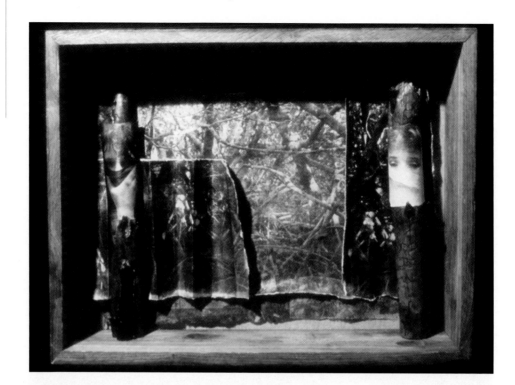

Judy Herzl

I Question

1990
mixed media,
photograph, cedar wood
15 x 20 x 5"

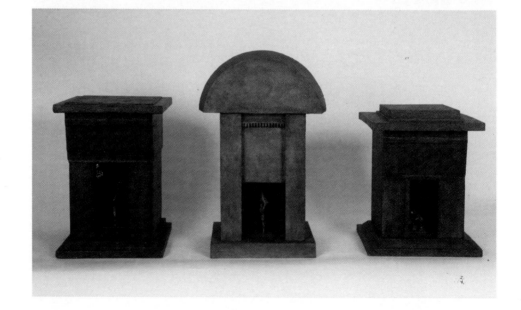

Tobi Kahn

Eccu
Brun
Eykhal

1985
Installation of three
works from the
"Shrine Series"
acrylic on wood and
bronze
15 ¹/₂ x 11 ¹/₄ x 12"
21 x 11 x 9 ¹/₄"
15 ¹/₂ x 12 x 11"

**Shirley
Klinghoffer**

Untitled: CT9-0981
(detail)

1998
installation—
slumped glass and text
dimensions vary

**Vitaly Komar
and
Alexander
Melamid**

*Temple for the Third
Exodus from Russia:
Remains of the Temple*
(detail)

1997
detail
36 x 36 x 24"

Geoff Laurence

T'Fillah
(1, 2 & 3)

1999
acrylic on wood
22 x 22"
22 x 34"
22 x 22"

Jane Logemann

Border T

1992
oil on canvas
78 x 60"

**Cynthia
Madansky**

On the Jewish Question

1998
metal, pounded letters
35 panels
10 x 10" each

**Judy Moore-
Kraichnan**

*Daibutsu and
Temple Mount*

2000
toned b&w photo
15 x 18"

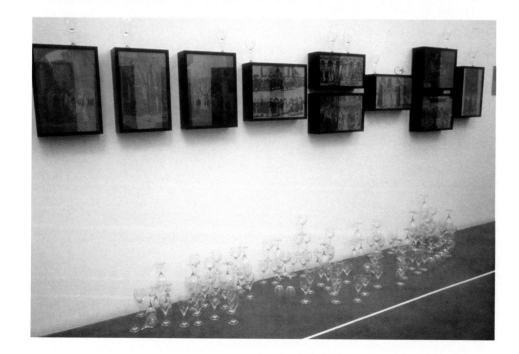

Devora Neumark

*Harrei At Mutteret ...
Harrei At Mikoodeshet ...*

2000
mixed media installation:
10 boxes with 10 b/w
photos, wine goblets
dimensions vary

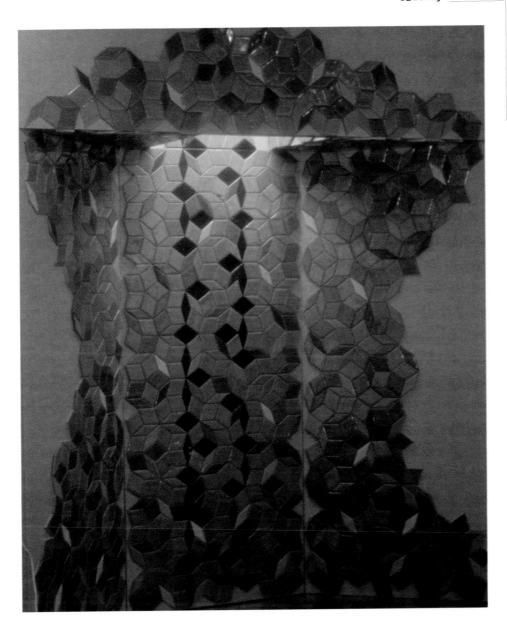

Cynthia Patterson and Hank Saxe

Ladder/ Shaddow/Light

2000
ceramic tiles, wood, and inset light
120 x 20"

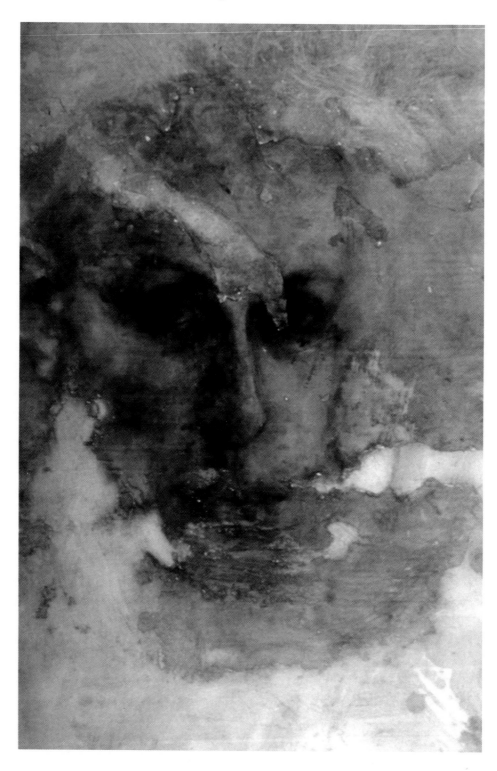

Judith Kim Peck

Cultural Obliteration

N.D.
oil on board

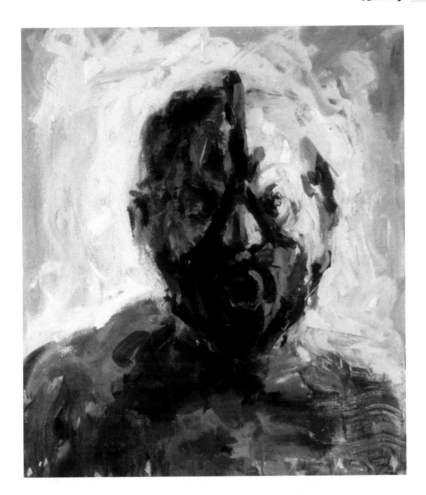

Carl Plansky

Self Portrait

N.D.
oil on canvas
30 x 24"

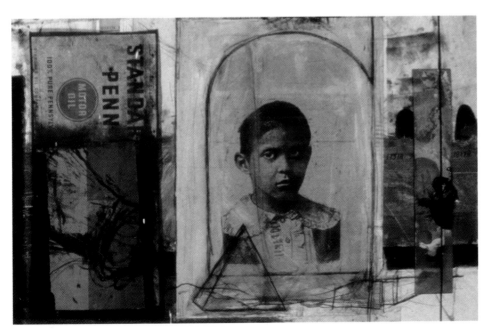

Ron Pokrasso

All Merican Russian Boy

1998
mixed media
22 x 35"

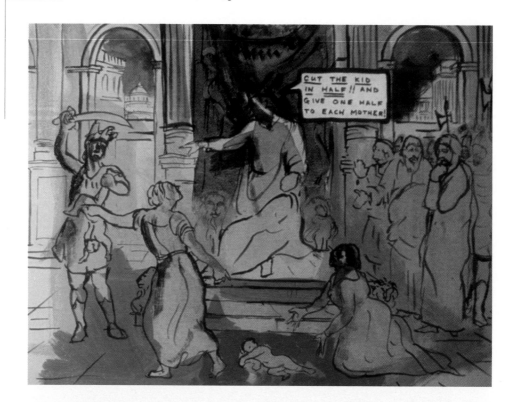

Archie Rand

*Solomon
(1st Kings 3:25) from
60 Paintings from The
Bible*

1992
acrylic
18 x 24"

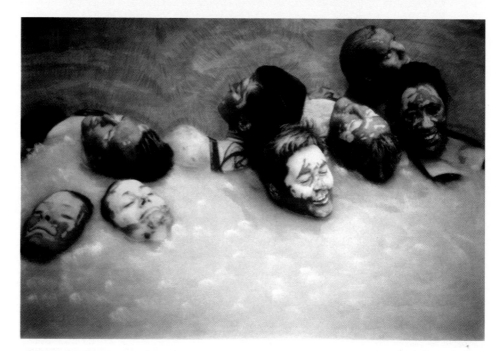

Marcia Reifman

Family

1999
hand colored,
toned silver print
11 x 14"

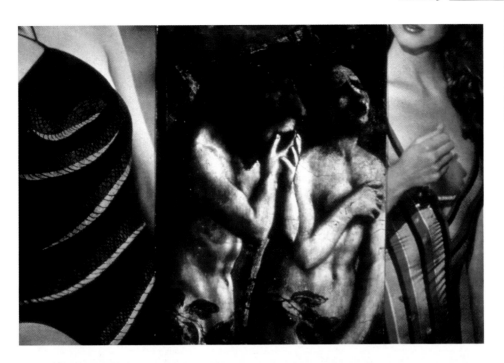

Susan Ressler

Expulsion

1984
cibachrome
11 x 14"

Shari Rothfarb

Water Rites

1999
video projection into a
pool of water

**Adrienne
Salinger**

*Gavin Y, Teenagers in
Their Bedrooms*

1990-93
photograph
30 x 46"

Susan Schwalb

Aishet Hayil

1993
silverpoint/acrylic/
gold leaf on wood
32 x 36 x 10"

George M. Wardlaw

Exodus II: Warning Signs

acrylic on aluminum
88 x 106 x 24"

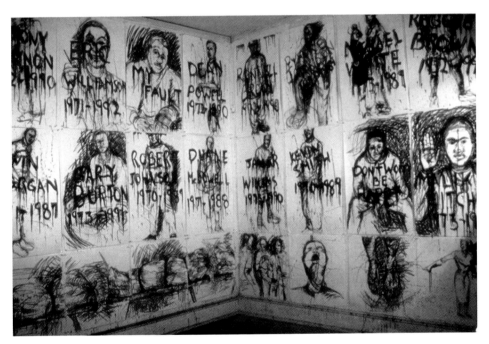

Joyce Ellen Weinstein

Dead Boys

1988-90
charcoal/oil on paper
each 26 x 40"

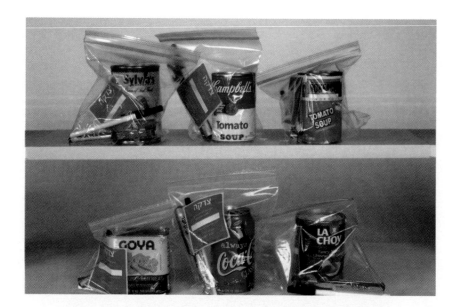

Allan Wexler

Tzedakah

1999
mixed media

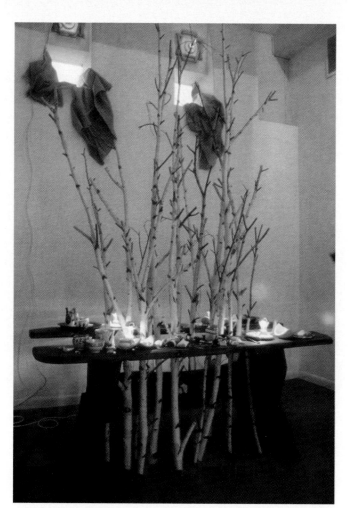

**J. Barry
Zeiger**

Seder Table

1997-2001
birch, mixed media
configuration varies

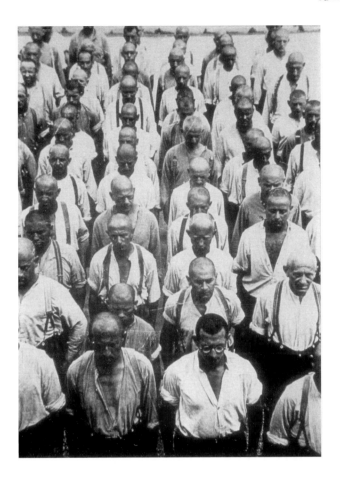

Donald Woodman

Male Prisoners at Roll Call

photograph
14 x 11

Donald Woodman

Canada

photograph
11 x 14

III

Jewish Artists and Edges
Jewish Artists and Edges

Jewish Artists and Edges

JEWISH ARTISTS AND EDGES

An edge is a boundary; boundaries are what we use to create a definition (since "to define" means, in Latin, "to draw a boundary around"); to be on the edge is to be between realms defined by lines of exclusion and inclusion. **Rose-Lynn Fisher**'s fascination with "otherness" in time, space, experience, *being*, places her constantly on the boundary between the selves which define her—artist, woman, Jew, American, Los Angelina. On the border she asks where precisely her place *is*, while allowing the uneasily answered question to contour her work rather than to paralyze her convictions. *"The metaphor of threshold is the thread of constancy in my work. As a point of entry and departure between the known and the unknown, a threshold is the internal structure of spatial, temporal and spiritual transition... Here the sacred meets the mundane, the absurd joins the poignant... a vanishing point becomes visible... Patterns in perspective create distance; patterns in time create tradition..."*

Fisher works as a painter in a manner that often combines different media as well as figurative with abstract elements. Her work plays with Renaissance imagery and the Albertian discussion of how to produce the illusion that, when one looks at a painting one looks through a window into space filled by volumetric figures and objects, rather than at lines and colors on a flat surface. Again and again her landscapes become topsy-turvy exercises in rectilinear perspectival geometries. "Doorway"(1995), for example, offers a hilly realm of rubix cube-like patterns across which a figure moves, carrying a pair of doors, so-configured to resemble a St Andrew's cross: the figure struggles along the horizon of a Golgothean landscape, suggesting Christ without outright stating it. But he is, then, what he bears: a doorway. He is the meeting of spiritual and aesthetic (divine and human?) realms.

Fisher's work as a photographer has taken her to diverse places on the external and internal edges of time and space. While visiting Israel several times since 1991, she turned to the relentless austerity of the Negev desert, the timeless quality of which served as a boundless spiritual centering point for re-locating in herself a sense of home by virtue of that "Homeland": what defines "home" and "homeland" for one with the varied layers of identity of which she is conscious? That identity includes an imprecisely but distinctly articulated Judaism and in turn connection to a people whose historical condition has been one of homelessness and fixation on a homeland of the distant past and the messianic future. In photographing the remnant of Morocco's Jewish community, in its Berber villages on the edge of the Sahara desert—particu-

larly its elders and its children—she has explored memory and loss, as she has recorded one among the myriad ebb-and-flow phases of Jewish history. In photographing the tombs of Moroccan Jewish holy men venerated by both Jews and Muslims, and in living and photographing in a Belgian Catholic community, she has addressed the boundary between humanity and divinity as it is approached in common across the diverse borders of faith.

Where do we come from? Where do we fit in? Where do we call home and how do we define home?—are ongoing questions for a dispersed people. The edge between past and future and between old world and new world is the point from which questions of belonging are raised by and for emigrants/immigrants of all times and circumstances. But few groups have endured so consistent a condition of that blurry-edged *betweenness* as have Jews. At the end of the nineteenth and beginning of the twentieth century, millions of Jews arrived to then-Palestine or to the United States from eastern Europe. **Ron Pokrasso** reflects on the end of that era in his mixed media "All American Russian Boy", the centerpiece of which (it is a triptych in form), is based on an old family photograph (ca 1927) from which he excised everyone but his father. But it is more than his father whom we see. We see the artist and we see ourselves, for in reshaping the flotsam and jetsam of the transitional experience of emigration/immigration into the materials that define the image, he defines himself and all of us, made up of the diversely assemblaged genealogies of our DNA and our dreams.

At the end of the twentieth century, with the opening up and then tearing down of the Iron Curtain, once again a substantial number of Jews poured onto these shores. Among the most famous arrivals are the painters and performance artists **Vitaly Komar** and **Alexander Melamid**. Refugees from the former Soviet Union, Komar and Melamid went first to Israel, where in 1978, in Jerusalem, they erected a red metal tower, surmounted by the five-pointed Red Star, which they labelled the "Temple for the Third Exodus". Within it they placed an old Russian suitcase – one of the suitcases in which they had carried their belongings in their exodus from the Soviet Union – and set it on fire. This "sacrifice of the Russian suitcase" was followed by the destruction of the Temple itself, crushing it into a small box-like shape upon which the star sits, the only intelligible fragment left. The remains of both Temple and sacrifice rest in vitrines. The Soviet Union has itself become a piece of past history, fit for a museum.

The artists prepared a pair of fragmentary gravestones, in Hebrew, with their own names, deceased as Soviet citizens, inscribed. They wrote a three page text—"The Book of Komar and Melamid"—in Hebrew, and inserted it in a copy of the Hebrew Bible, between the books of Prophets and Sacred writings. There is a pun: "Komer" means "priest"; "Melamid" means "teacher" in Hebrew. The transition in Judaean history from leadership by prophets and priests to that by scribes and scholars—teachers—begins after the return from Babylonian exile. The artists' arrival to Israel echoes such a return from exile, even as it echoes the earlier Exodus of the Israelites from Egypt: layers of echoes make up the history of which they are an integral part. Indeed, having moved on to America Komar and Melamid have further considered that

history and their part within it, as the range of their projects has continued to expand. They have carried the ashes of the past with them, and so it can't be forgotten. "The Remains of the Temple" is a crushed compendium of the identity that they took with them from Russia to Israel and to the United States. But what *is* that identity? Jewish artists in the former Soviet Union were, since 1934, subject to a peculiarly difficult struggle with identity. *All* artists desirous of expressing their inner aesthetic selves while surviving *as artists* by towing the Party line were aesthetic *marannos*—Crypto-Artists—creating official art publicly, but creating unofficial art, the art of protest, behind closed doors, for a small loyal following. For Jewish artists who were part of the unofficial art scene, the world often had three, not two simultaneous conditions: that of operating within its outer and official elements, that of being part of unofficial art circles, and that of being Jewish within both official and unofficial non-Jewish reality.

The complexity of the Jewish three-world Crypto-Artistic condition could not simply be left behind upon arriving into the United States. On the contrary, whereas *there* such artists were viewed as *Jews*, not *Russians*—and they certainly did not think of themselves as *Soviets—here* they are viewed as *Russians*. *There*, they had strong support from a very small but close circle; *here* the art world is too big to be interested in any but the lionized few. What identity should they embrace once they are here, but not yet American (and how long does it take to *become* American) but also no longer either part of the Soviet scene or part of the protest scene, since emigration and/or *perestroika* eliminated many of the specifics against which they had formerly protested?

Komar and Melamid are in fact an exception to this troubled rule. While still in the Soviet Union, they became known for their 1972 creation of *SotsArt*, an allusion to American Pop Art and a satire of socialist (*Sots*) propaganda and its art. And they have been successful almost since their arrival in America, capturing the interest of the art public with their clever visual commentaries on icons of Soviet history and Euro-American history and art history. They refer to this work as "Anarchistic Synthesism". In recent years they who visually toppled the sacred trinity of Marx, Lenin and Stalin again and again in their paintings, have incorporated into their artistic experimentation the images of those images as they have been toppled by the fists of *glastnost*. In 1995 they began a collaboration with an elephant, Renee, in the Toledo, Ohio, zoo, and since then with other elephants: teaching them to paint and exhibiting their work.

The edge between human and animal creativity reached a particularly ironic apogee when Komar and Melamid were invited to *represent Russia* at the 1999 Venice Biennale, and they exhibited works by three elephant artists. Perhaps not by coincidence, during this same recent period, they have also redefined themselves—not as Russians or Soviets or Americans or any narrow national or ethnic box into which others might place them. *"We realized that we are, when all is said and done, Jews, as we migrate from one place to another and take root in one culture after another. The cosmopolitan tendencies of which our grandfathers would have been accused defines us, in the most positive and dynamic way!"* The pieces of their identity would not fit easily into a pile of suitcases or onto an elephant-sized canvas.

Komar and Melamid are part of the array of Jews who have arrived on these shores in the past quarter-century, bringing questions of past and future and of roots. **Marilyn Cohen** has focused on Jews who came to America within the last 125 years. She has also focused, as a separate matter, on the disenfranchisement of women in America. In one remarkable series of collage-paintings—*Where Did They Go When They Came to America?* (1989-94)—she presents the stories of one Jewish family in each of the 50 states. Based on oral histories and images in old photographs, these reflect more than a century of everyday life and shared experiences. Cohen's work is both historical document and aesthetic tour-de-force. One would hardly imagine that it is collage, so delicate are the gradations of chiaroscuro and color range. Figures famous and obscure, wealthy and impoverished, learned and untaught peer out of the many-faceted mirror she holds up to the lives of Jews in this brave new world.

"Aloha Gothic" depicts Nachman ben Joseph Usheroff, who migrated from Tsarist Russia to Harbin, China in 1905, where he worked on the trans-Siberian railway. In 1928 he sailed for Hawaii, where his wife and daughter were able to join him two years later—as part of the *Chinese* immigrant quota. We see the happy couple – in a pose echoing Grant Wood's famous "American Gothic"—among the flowering trees and the red-and-white-American-flag-striped awning of their Oahu home. There, on that edge of America, the strapping blacksmith made ironworks for the Dole Pineapple Company and the Royal Hawaiian hotel and for the Oahu prison—and for the *mikvah* (ritual bath) in his backyard.

In a second series completed in 1997 called *Teach Me the Songs My Mothers Sang to Me*, the artist depicts an array of women who have defined myriad aspects of the American past. Eighteen of them, each in her own frame, have made an impact in aspects of twentieth-century life not often associated with women—like aviation and baseball—and often obscured by the shadows of male counterparts. One might say that "Annette Retablo: Our Lady of the Convoy" combines aspects of both of Cohen's series. Raised on a dairy farm begun by her parents in upstate New York, which she and her husband eventually took over, Annette volunteered to help out on a humanitarian mission to Central America in 1989. That put the 72-year-old Jewish grandmother behind the wheel of a 14-year-old Mercedes bus which, at a dusty, heat-filled 16-hour-a-day pace, carried medicines and vitamins, toothbrushes and blankets, diapers and soap, into the unpredictable landscapes of Mexico and Guatemala, Honduras, El Salvador and Nicaragua, to women and children in refugee camps and union halls, in orphanages and corn fields. We see her as a *santera*, as *Central* American Gothic: an icon clothed in the blood red of passionate involvement, surrounded by the attributes of the worlds whose borders she has traversed, surmounted by an angel-held banner.

Mel Alexenberg often uses the images of angels—which he computer-generates, based on those in Rembrandt's version of Jacob's Dream—in conjunction with banal advertisements for food, in order to suggest art as a connector between heaven (angels) and earth (food), by way of word-plays in Hebrew (for the root of all three words—food, art and angel—is the same). He also uses art as specifically American political commentary on the relationship

between heaven and earth. In this exhibit, Alexenberg's interactive "Divine Retribution" offers newspaper front pages from three moments in President Clinton's political life: the day before and after his 1992 election and the day of the impeachment decision. Below these mounted clippings, we read that the President brought back a substantial amount of earth from Israel to be offered as "gifts"—soil from the Holy Land—to political patrons. The artist's implied commentary is that the impeachment was divine punishment for abrogating God's will by taking away and giving away pieces of the Promised Land to those to whom it was not promised—and the viewer is invited, tongue-in-cheek, to carry off a scoop. Alexenberg puns on the idea of "Four Corners of the Land"—a biblical phrase used with reference to that Holy Land – by selecting the news headlines from the four corners of the United States. He thus also implicitly comments on the issue of Homeland/Promised Land which has, in many Jewish circles, placed Israel and the United States in either opposition or apposition since the end of the nineteenth century.

IV

Edges of Connection
and Disconnection

Edges of Connection
and Disconnection

EDGES OF CONNECTION
AND DISCONNECTION

In all of Alexenberg's work the profane and the sacred meet on multiple levels, and America is critiqued from the comfortable perspective of never doubting one's right as an American to *offer* critique. In all of Cohen's work the geography and history—the people—of America are torn apart and reconstructed, the elements of time and memory layered literally by her painting-collage technique. The question of who and what we are is linked to that of whence and whither we travel by the shapeless fragments which she has shaped. Who, what, whence and whither are constants of Jewish thinking, within and beyond American time and space. **Sy Gresser**'s "Tribal Faces (Menorah)" asks who and what we are in carved steatite, extending from the personal to the universal by way of certain Jewish—qua *tribal*—specifics. The faces represent different races and ethnic types, (Jews offer no specific racial or ethnic typology, in spite of those who would assert otherwise), held together by the most consistent symbol in two millennia of Jewish art, the seven-branched candelabrum. The faces, like so many of Modigliani's—one eye open, the other closed—have both outer and inner vision as they are literally connected to each other in a circle (universal symbol of perfection and completeness) that is incomplete, suggesting that there remains work for us to do.

One of the ways in which **Arlene Becker**'s photography connects individual to individual and group to group is by observing the common ground of *disconnection* upon which we often stand. In a work like "Black Guy and White Guy" she has contrived two opposite figures—Black/White, Young/Old, without hat or glasses/with hat and glasses, with hands hidden/with hands revealed—who share the isolation in which each sits at the same kind of table eating the same kind of food. Indeed the food is emphasized by the only particle of color in the image, that of Ronald McDonald's orange clown-hair. The context of this scene is the ultimate *gastronomic* American Icon. It has become the symbol of America across the planet, even as the issue of the intermingling and separation of races also symbolizes America. Perhaps not surprisingly, other Becker images play on the idea of American icons—she has driven Marilyn Cohen's focus around another turn—such as the double-exposed repetition of James Dean imagery (an *infinitizing* repetition that therefore pours us into the timeless infinite realm of the Other into which traditional icons are the windows). This is the reverence of "James All

Over Again". Her "Elvis in Jerusalem" turns *that* American icon toward the Holy Land (Land of Grace)—where, indeed, on the edge of Jerusalem, the Holy City, a food stop/gas station offers the largest, most diverse collection of Elvis memorabilia outside of Graceland.

Judy Moore-Kraichnan connects the edges of realities identical to or parallel to those which draw the focus of Becker, by visual mergeance, *"...like chamber music in which two or more instruments combine to produce a wholeness not apparent in the individual voices... Blending images taken at different times is a way of bringing time into an otherwise static medium."* "Hebron Road" and "Western Wall and Tunnel" both merge the past and the present—continuity and change—in the context of Jerusalem as seen between 1849 and 1917 and as seen again between 1993 and 1998. In the first image, an 1895 photograph by Larsson, with a caravan of camels, is implanted within the 1994 photograph by Moore-Kraichnan: automobiles seep from the newer image into the older. In the second, the double-exposure effect yields a play on the idea of perspective: our eyes follow into the picture toward the vanishing point, and thus the notions of reality and illusion—central to the very air of Jerusalem, thick with the possessive claims of diverse religious groups and crawling with both banal tourists and would-be prophets—overwhelms the viewer's eye and mind. The aesthetics of Albertian perspective and of Judaeo-Christiano-Islamic spirituality meet in the depths of the wall.

Another angle of overlap between place and tradition emerges from the photographer's "Daibutsu and Temple Mount". The southwest corner of the Temple Mount wall—a central focus of archaeologists for the past hundred and fifty years, seeking the layered history of the Sacred City and its peoples—rises, its edge like a pyramidal point, through and above the head of the Buddha. The two images soak through each other. The viewer is reminded of the enormous attraction Buddhism has come to hold in the late twentieth century for (particularly American) Jews, an astounding number of whom have embraced Buddhism while remaining Jewish. (Since Buddhism offers no God, but the model of the Buddha as one who has achieved enlightenment, there is no necessary contradiction in this). The image also suggests the question: are we at the edge of a new synthesis, another corner in the turns and twists of the spiritual history of Judaism?

For spiritual syntheses have certainly been part of Judaism's past. None has been more profound than that defined by the long history of the Sephardic Dispersion extending from Spain and Portugal in the 15th century to various other parts of Europe and America into the 20th century. Nine years ago, the quincentennial of the expulsion of Jews from Spain and of the first voyage of Columbus sparked a bonfire of interest in and research into the history of interface between the world of Jews and the world of Native Americans, since both were so strongly and unhappily affected by the events of 1492. One particularly interesting interface which such research has argued is this: that when the Inquisition arrived in Mexico in the late sixteenth century, many of those who, having re-opened their lives as Jews once they left Spain or Portugal, now ran the risk of trial and torture as heretics and went back into hiding in two

ways. They fled to the furthest available corner of Mexico—New Mexico, which one day would become part of the United States—and they hid their Judaism behind the same sort of veil of Catholicism that had obscured their ancestors a few generations earlier. They became Crypto-Jews, and their own descendants would only recover their identity with some clarity in the late 20th century. Some of the "proofs" for generations of hidden Judaism are customs—like removing a goblet and candlesticks from a cupboard on Friday evening, filling the goblet with wine and kindling the candles and not replacing them in their secret storage until Saturday night – and celebrations, like the feast of St Esther (heroine of that eponymous biblical book who was, in a distinct sense, the first Crypto-Jew). And gravestones, marked not only with symbols that might be construed as both Jewish and Christian (like the cross and the Star of David) but inscriptions in both Latin and Hebrew.

Cary Herz' 1994 photographs of such gravestones are part of the record of a particular Jewish edge – between being hidden and being revealed as a Jew, in this case visually marked on the marker of the edge between life and death. Her series of *Crypto-Jewish Burial Sites* is a visual parable of the struggle for and against self-assertion that has marked Judaism historically and is present among even the most apparently free-to-express-its identity Jewish community the diaspora has ever known, the American Jewish community. The details of this particular narrative within the larger Jewish story are more complex, still. In the bare decade since the "discovery" of New Mexico's Crypto-Jews, at least one scholar (Judith Neulander) has come forth to argue that these are, in fact false Crypto-Jews – crypto-Crypto-Jews – who took on the guise of Crypto-Judaism at the end of the 19th and beginning of the 20th century (for reasons that fall outside this discussion). The gravestone bearing the first five commandments of the Decalogue may have been removed from a synagogue where the other half of the stone may still be seen, and not created originally as a gravestone. The edge, then, may be double-edged.

Whether such images represent true Crypto-Jews, descended from refugees from Spain, or whether they reflect a more recent form of false Crypto-Judaism, they signify the boundary between individual and group and the edge between true and false knowledge of one's roots, as well as between memory and forgetting. For the artist, *"…this photographic essay has redirected me back to my own spiritual center and my Judaism. It has connected me with my own past."* If the question of identity posed by these images and their argued context may never be answered to everyone's satisfaction, then her work is simply like so many other definitional questions pertaining to Judaism: without resolution.

Synthesis and the shaping of category have a precise echo in the life and work of **George Wardlaw**. His "Exodus II: Warning Signs"—one side swarms with locusts to the careful eye—is simultaneously a large, black aluminum step-pyramid and a stylized representation of the mountain which Moses ascended. It evokes both the Egypt whence the Israelites fled and the place in the wilderness where they were reformed into a covenantal people before completing the return to the Promised Land. It thus recalls the synthesis of the ethnicity of

Moses—the Israelite raised in the ultimate Egyptian household – and the spirituality of Jethro, his father-in-law, who joined the covenantal community when he heard about "all the goodness that God had done to Israel" (Exodus 18:1-12). It is part of a series of fourteen large sculptures and over a hundred paintings which *"[helped me] to better understand some facets of Jewish history and identity, and to reaffirm my own... And foremost, I wanted to make work that had a religious theme but that manifested itself primarily in spiritual presence and awareness, work that might cut across diverse religious boundaries and reveal a common spiritual concern and work that crossed contemporary art with cultural history"*. The edge between the realities of servitude and freedom, wilderness and homeland, covenantal obligation and covenantal promise, ethnic and spiritual identity; reflects edges of Wardlaw's own life. Brought up Baptist in a small southern town he was eventually inspired, in part by contact with the Judaism of one of his key mentors, Jack Tworkov, to convert to Judaism years ago.

Jews and Jewish artists have taken varied spiritual and aesthetic paths. For some the condition of being Jewish – of being on the edge of the non-Jewish majority—is a stepping stone to the larger discussion of *other* groups who are on the margins in different ways. **Adrienne Salinger**'s two series represented in this exhibit carry toward two different peripheries. Her striking images of individual *teeth* confront us, tooth in cheek, with a neo-Warhol cutting edge—or is it the tearing edge?—of aesthetics: we see a tooth the way perhaps not even most dentists do, as a work of art. *"Each tooth, photographed in isolation, represents an individual personality, a character, a story, a loss"*, (and for some, the loss and particularly the medical malfeasance associated with the Holocaust). On the other hand, in her series on *Teenagers in their Bedrooms*, each of her subjects has created his or her own world, a refuge apart from mainstream reality. Salinger has splendidly captured the sense of being peripheralized (or believing that one is) by the oppressive realm of grown-ups, of being caught between the hormonal patterns of childhood and adulthood, but of being free from it all in the sanctity of one's bedroom. The inscription across "Gavin Y"'s bedroom wall—*Subhumans*—summarizes this succinctly. It also expresses the sense of struggle to shape an identity as a fully-accepted citizen of the human race, and has an obvious coincidental Jewish evocation. But one on the inside of the teen-age world would know immediately that this is simply the name of a popular rock band!

To represent members of a group of which the artist is not herself a part requires a particular breadth of spirit. Salinger is able to convey through not having forgotten the often troubled center of the teenager's world by empathy and not just sympathy. **Joyce Ellen Weinstein** focuses on the sharp edge of some teenagers' worlds which she embraces as a family without genealogical lines. She taught in a mostly African American high school, where any number of the students to whom she became emotionally connected did not make it through school—alive. The school and its students are among the many abandoned by an America whose educational system became increasingly bifurcated between those who have

and those who don't—between those who will live and those who might die—through the presidential administrations of the 1980s. Weinstein began a series that memorialized *The Bold Dead Boys*, in 1988, continuing to work on it through mid-1990.

"As I watched the community of youngsters disintegrate around me – twelve of my students were murdered during my six-year tenure – I became more aware of the need for community and of how this community acts like a glue to hold its members together... [This] brought me to a deeper understanding... of my own community as a Jew."
Sixteen portraits and eight smaller details were done with charcoal on paper and dripping red oil paint. The colors of purgatory—but leading to no salvation—the colors of death and blood, offer Malcolm, Kevin, Robert, Dean and the others. Their names and the dates of their births and deaths—none older than 21 years of age — tell a poignant story beyond words. The blood of these young men, part of the artist's extended human family—and *ours*, when we elect to remember them—cries out, but the society from which they have been written out is blind and so they are snuffed out even as they have been written out.

Being written out connects various groups through common disconnection. **Shirley Klinghoffer**'s work in part comments on the position of women not as written out but as narrowly scripted in American society. Her "Doormat" is a black cast rubber rectangle shaped as 15 Barbie dolls: paragons of soulless body-perfection in a white Anglo-Saxon suburban realm, where physical flaws and opposition to male dominion are even more scarce than the mud one's shoes might bring into a spotless entry hall. If this work carries us over a threshold of humor, Klinghoffer's untitled slumped glass installation, molded from the torsos of women who have survived breast cancer, edges us back to that ineluctably serious boundary between life and death. We are reminded of the images of breasts offered in shrines in various parts of the Christian world, to Saint Agatha, by women who have survived one breast-related malady, including barrenness, or another. But these are life-sized actual molds, not miniature symbols. The current exhibit shows three pieces from an 18-part series: eighteen is the number that, in the Jewish tradition, symbolizes *life* (every Hebrew letter has a numerical value; the two letters that comprise the word "life" add up to eighteen). It is the combination of her father's experiences as a Jewish refugee and her mother's as a fighter against a long illness that, the artist has asserted, honed her sensitivities toward vulnerability and strength. Those sensitivities yield the tension between capitulation and triumph which this work exemplifies, with its transparent, glowing figures and the texts accompanying them from survivors that reflect both on a lonely sense of marginalization and on victory over deathly despair.

*Edges that Cut
within Jewish Tradition*

EDGES THAT CUT WITHIN JEWISH TRADITION

Rachel Giladi also comments, again and again, wryly, on the definitional boxes into which women have traditionally been stuffed. Her small dark installations, "Sterile" and "Hygiene" reflect, respectively, on the ages-old valuing of women only in terms of their reproductive capacities—she has reduced "woman" to udders and nipples—and on the paradoxic association, by millennia of men, of the monthly flow of female blood with both birth blood and uncleanness. Tampons have become toothbrushes. This last notion cuts across parallel religions and cultures: for Christianity, the association of birth with sex and thus with Original Sin; for traditional Judaism, the concept of contact with menstrual blood as impure. But the associations are male-made, and reflect male fear and frustration at women's ability to bleed and yet not die, month by month. Giladi's "*Mamzer*"—the Hebrew word for "bastard"—plays further on centuries' old universal prejudices and traditions, by means of a specifically Jewish vocabulary. It is a plastic toy store baby, with a hospital identification number around its wrist. The use of the Hebrew term makes inevitable an association with the long technical discussion in the Talmud regarding the status of the bastard in traditional Jewish society—a limited, negative one, on the *edge* of the community. On the other hand, by linguistic paradox, the term has come to be slang, in both Hebrew and its Yiddish sibling, for someone who is terrific, wonderful, successful—which all babies are, particularly in the minds of the parents gazing down at them. The implications are large for the negative and positive associations attached by society to a creature with no control over the circumstances into which s/he is born and on language that marks the edge between clarity and obscurity.

The co-existence of positive and negative, particularly where women are concerned, is hauntingly addressed in **Shari Rothfarb**'s video installation, "Water Rites". The artist projects twenty-seven comments regarding the significance of the *mikvah* – the pool of ritual purification into which Jewish women have immersed themselves for endless generations, most often before the Sabbath and after menses (again, then, part of the intention is to reflect on the supposition that menstrual blood is *unclean*)—into a tiled, *mikvah*-like pool of water. The quotes are not just commentaries, but narratives, including one which speaks of a group of women who insisted to their Nazi executioners that they be allowed to immerse themselves

properly, cleansing themselves before crossing the border from life—before being shot to death. Landscapes of lush and provocative imagery form a backdrop for the speakers of the words, *"transgressing the boundaries of time and space to reflect the many different experiences and points of view about Mikvah"*—including footage of ancient and modern *mikvaot* from Masada, Jerusalem and the Galilee. In a unique combination of word and image, stasis and motion, stillness and dynamism, Rothfarb's work suggests a range of understandings, from onerous to uplifting, of this aspect of Jewish tradition.[5]

With a related but differently angled direction, **Devorah Neumark**'s work focuses on the two edges of Jewish married life—wedding and divorce—with irony and wit. "*Harrei At Mutteret...*"—"Behold you are released..." are words of divorce, echoing the words spoken by the groom, as he places a ring around the bride's finger: "*Harrei At Mikoodeshet [lee]*" ("Behold you are sanctified [unto me]...."). Neumark's installation follows women through the passage between marriage and non-marriage, a metaphor for the passage between entitlement and non-entitlement. Framed transparencies of historic illustrations by unknown (presumably Jewish) and well-known artists (not Jewish, like Rembrandt; and Jewish, like Moritz Oppenheim) depict the joy of the Jewish wedding. There are ten of these photo boxes, as if we are observing a women's *minyan;* each is surmounted by a wine goblet. The breaking of the wineglass at the culmination of the Jewish wedding ceremony (wine being the most traditional of Jewish symbols of joy) is intended to recall, even in the midst of happiness, the destruction of the Temple. Seven of the goblets (the number of blessings recited at the wedding, and the number of times the bride walks around the groom) are inscribed with the Hebrew words of release. Scores of goblets complete the installation, stacked and pulling from the wall in a semicircle. The shattered forms of some recalls simultaneously the relative ease of divorce (when compared to the Christian tradition) in Judaism, and its difficulty, indeed impossibility if the husband should not desire it. While a wife can, under defined conditions, demand a divorce, the husband may refuse. If Judaism is a historically marginalized minority within Christendom, women are a historically limited majority within Judaism, particularly as defined by the beginning and even moreso the ending of a marriage.

Such commentaries are rich with paradox and as narrow as Judaism at its narrowest and as broad as humanity at its broadest. **Helene Aylon**'s "Epilogue: Alone with my Mother" might be said to summarize their beginning point. She offers a series of five books—like the five books comprising the Torah, foundation stone of the edifice of Judaism. But in *her* texts she has singled out and deleted or highlighted passages that reflect a traditional negativity towards women. In this the artist highlights her own struggle (she comes from an Orthodox background) to reconcile her religious and gender identities as she reshapes what is traditionally understood to be the word of God into a more female-inclusive form. Can God have uttered the words which she has excised, or do they derive from God's male conduits and interpreters? One might argue—the title of a similar installation, "The Liberation of God" does so explicitly—that she frees God Itself from the male-oriented bonds that have traditionally limited God.

If we are to move forward, we must reform as much as conserve, as Judaism has repeatedly done through its history, if we are not to *further* marginalize the female half of the Jewish world and render the task of continuity that much more challenged (and, the artist adds, makes a posthumous victory for Hitler that much easier).

Reflection on the place of those on the margins of Judaism within its traditional structures is not only a concern of Jewish *women* artists. **Geoff Laurence**'s triptych, *"T'fillah"*—meaning "Prayer"—breaks the body of a woman into three discontinuous parts, around each of which is wrapped the leather thong of the phylactery box, which a pious Jewish male wraps around his arm and forehead for the daily morning prayer, literally fulfilling the Torah injunction to "bind it for a sign upon thy hand and place it as a frontlet between thine eyes". Those prayers include words thanking God "that He did not make me a woman". Thus the generalized issue of women as commodities (bodies made of parts without souls within them) and the specifics of woman-exclusion or even negativity toward women in specific corners of Jewish ritual are intriguingly interwoven with the suggestion of contemporary sexual mores: the nipple ring reinforces the notion that the leather thong plays a role in sexual bondage, which then becomes a pun regarding gender bondage and "binding it... upon thy hand" in traditional Jewish settings. Which are the ties that bind and which are those that bound?[6]

*The Edge of Memory:
the Holocaust*

THE EDGE OF MEMORY:
THE HOLOCAUST

Laurence's Jewish background is edged interestingly. He grew up virtually commanded by his father—who had, as Laurence's mother had, escaped the Holocaust with deep scars—to forget that he was Jewish. *"...whilst constantly lecturing [me] from the age of four about the horrors of what he and others went through, [he] was vehemently anti-semitic and refused to answer the obvious questions that occurred to me about his background...I was told not to emulate 'Jewish' traits. My father even went so far as to banish garlic from the kitchen because he said it 'smelled of ghetto cookery.'"* Laurence's address of Jewish subjects reflects a rebellion against the identity strictures under which he, albeit male, grew up with regard to participation in any aspects of Jewish life. His work in this exhibit addresses the Holocaust in an oblique manner—because of the life experience that informs it, rather than because of the subject that it overtly presents. That subject has directly drawn many other Jewish artists, particularly during the past two decades—each differently.

Judy Chicago's enormous *Holocaust Project* literally takes the world apart (the method reflects the content) as the Holocaust did, and puts it back together in a geometrically-skewed fashion. In the seminal image from the series created together with her husband, **Donald Woodman**, each faceted edge of the image thrusts out at the viewer, asking unanswerable questions regarding God's presence or absence and the term "humanity" as it applies to the human role, active and passive, in the Catastrophe. The "Four Questions"—a study for part of the larger work—turns on its edge the line between photography and painting as it turns on its head the issue of continuity to which that phrase "four questions" traditionally alludes. For they would be the questions asked by the youngest child at the Passover seder table for which the answers are the narrative that shapes the seder, the *Haggadah*. If the theme of the seder is God's redemptive power, the turn of the Four Questions toward the Holocaust induces us to wonder where that redemptive right arm and outstretched hand were half a century ago?

Jay Zeiger's installations offer parts of answers—in both Holocaust and Passover Seder contexts. "Resistance" fills the lower part of a light-ringed window of broken panes—the sharp edge between outside and inside, but in this case, perhaps, between past and future—with bones. We cannot tell whether they are human or not, but perhaps that doesn't

matter: to the Nazis, Jews and other victims were no different from animals. On the right corner of the sill sits a blood-red pomegranate, symbol of fertility, of physical continuity, due to its myriad seeds—and in the Jewish tradition offering a particular association with spiritual and intellectual continuity: the rows of seeds have for centuries been likened to rows of studying Torah students. Through the broken frames of the upper part of the window, rows of glowing colored beads shine, (some real, some plastic), suggesting the endless range of ways and places in which Jews have resisted those who would exterminate them—both during the Holocaust and across Jewish history at large.

In a related yet different way, Zeiger's "Seder Table" bursts with continuity: birch boughs thrust through it, from floor to ceiling. The table is covered with diverse candlesticks, their whispy flames symbolic of souls now gone, and crockery, together with myriad other evocative objects—the flotsam and jetsam of diasporatic existence—most of it broken, as the table itself is broken. But the table is broken by the trees. Light blue cloth (the color of the sky, of the *tallit*, of the stripes and star of Israel's flag—in short, of hope) flutters from the wall, illuminated by bulbs framed by blunted Stars of David. The installation is a splendid study in the tension between wholeness and breakage, between continuity and interruption. In seeing Zeiger's two works together, as part of one larger idea, we see the pre-eminent role of the Holocaust in the historical efforts to destroy Judaism, and the double effort to defy destruction. The specifics of resistance to the Nazis, risking certain death, is one. The other is the general context of Passover as a festival that rejoices in the overwhelming of would-be destroyers and, in the yearly remembering and retelling mandated by the Torah, making the past live in a continuous and eternal as well as vital present.

Survival is expressed in the very fact of so many varied and significant modes of reflecting on the Holocaust and its ramifications. **Donald Woodman**'s photographs offer ironic commentary on both the pride-filled photographic record-keeping of the Nazis and their dehumanizing goals. The almost anonymous rows of men in the archival "Male Prisoner Roll Call" are juxtaposed with the nearly undifferentiatable rows of contemporary hats shot in "Canada"; the vat of limbs soaking in formaldehyde in the archival "Medical Science" lie side-by-side with Woodman's own photograph of the "Autopsy Table at Natzweiler". Men as hats, human limbs torn for "science" in defiance of the Hippocratic oath – and the now-pristine platform of such horrific anti-medicine – are all part of the Nazi machinery that was part of the human capacity for positive or negative creativity.

Dorit Cypis' photographs offer analogous visual arguments. Her *Aesthetic Lessons* series is, at first glance, a group of abstract plays with line and form, curved shape and dark/light contrasts. Slowly perhaps, we realize by closer examination and by her context-suggesting subtitles, that these are piles of hair and piles of eye-glasses, suffused with a familiar horror. These can only be piles gathered, stored and half a century later displayed in the extermination camps that were the apogee of Nazi scientific creativity. Within those camps, the

unimaginable was not only imagined but enacted by men, like Joseph Mengele, who used the word "Dr" before their names without irony or self-consciousness.

Cypis' *Hybrid Eyes* series is simply an eerie and fascinating play on re-visioning familiar elements—what could be more familiar to our eyes than *eyes*?—in unfamiliar combinations that have as their visual purpose to make us look and look again, to questioning whether our first vision was a true or false vision, after we have *re*-visioned. This is a further play on the re-vision principle encompassed by pop art and its various progeny. But in the context of the experiments with eyes, as with other body parts, in the Nazi camps, these enormous off-eyes are more *disturbing* than merely disturbing. They refuse to leave us as we move away from them. The are, at the same time, simply a metaphor for the artist herself, a hybrid of her Israeli, American, Canadian parts (she holds three passports) which are ultimately part of her larger, simply human concern: *"... The journey is both visceral and virtual, discontinuous, full of confusion, elation, promise, conflict, dead-ends and gateways. Who is seeing? Who is remembering; whose memories? ... We navigate memory through time in all directions, wanting to remember, craving to forget. Stories which cannot be held by narrative erupt from once silent spaces. ... I use [mixed] elements to charge the given space into a place of active engagement, a time capsule in which the viewer may experience their seeing, remembering, knowing..."*

Julie Dermansky and **Georg Steinboeck** disturb us from a different angle. One part of their installation would be painful enough, offering Dermansky's intense orchestrations of paired images: an old black and white photograph of Rudolph Hoess, commandant of the Auschwitz-Birkenau extermination camp, with that in color of a pretty little girl, dressed, flowers in hair, as if for first communion, but recalling the pagan rituals and celebrations that were part of the *Hitler Jugend*; or the silent tower of the Lublin Majdanek concentration camp, in an old black and white image, juxtaposed with the full color contemporary graffito of swastika and crude hangman's noose around a star of David. But not far from these *still* images are a series of video monitors in which there is constant *movement*. The movement is eating. (For the third time in this exhibition, food is a medium of the message). Close-up images of people eating – in the Auschwitz Museum Café – stuff our eyes. *"An Australian woman caught me taking a photo of her and her children eating lunch. She asked me 'we seem rather gauche eating here?,' answering her own question by asking it. She hadn't thought about what it meant to be eating lunch at Auschwitz."* where people were systematically starved to death and then placed in ovens. The banalization and profanation of memory itself, that most sacred and extraordinary of human qualities, the transgression of the sharp edge between different forms of horror, confront us.

Saul Balagura's "The Wait" offers starved horror as the edge between life and death to which an uncountable number of humans were pushed by others in the Holocaust.

*I have lost track
of how long it has been,
I have lost new
and old friends
to hate and disease,
I gave up counting their tears
while mine dried up in despair,
I no longer look up
at the stars,
and the Sun cannot
heat up my entrails.
If I walk one day free
through those gates
will I be in or out
of this insane world?
I no longer walk
I no longer can love,
I only can wait.*

The victim, waiting to be relieved of a life of unmitigated pain, offers a particular unconscious irony when seen side-by-side with the artist's "Yeshua Preparing a St Peter's Fish" to which "The Wait" bears such a strong formal relationship: bony shoulder to extended arm, bent back to down-turned head. We have circled around back to Chagall: Jesus has re-become a Jew *this* time by way of his Hebrew name; his suffering to come reverberates from the suffering of his nameless co-religionists. Moreover, Balagura's painting intentionally echoes the early (1904) Picasso "Woman Ironing", among the last of the master's "Blue Period" works in which he focused with particular sympathy on the downtrodden. There is, then, a double equation. First, victims of oppression (like the woman ironing) are equated with victims of oppression (like the Jews) and the figure of Jesus (who was a Jew put to death) with Jews (who were put to death especially in the context of the Holocaust). Second, by way of the visual relationship between the two Balagura works and between his "Yeshua" and Picasso's "Ironing Woman" the outstanding cultural accomplishments of western civilization in the twentieth century (symbolized by Picasso's work) are pushed abruptly up against the wall of the most heinous and perverse twisting of our creative capability (symbolized by the Holocaust).

Jews have suffered historically in too many non-Holocaust contexts, and too many non-Jews were also victimized by the Nazis. **Judith Kim Peck**'s portraits, wrought with the delicate sensibility of the *cinquecento*, reflect both a skilled hand and a broad frame of reference. *"It is the tales of the survivors who are but innocent victims that enable us to*

knit together a more complete and revealing factual portrayal. I paint these witnesses. I try to show that the people who lived through these monstrous actions were both average and extraordinary people, in the hopes that the present day viewer discovers a bond."

Faces float in a kind of spaceless space. They encompass the generalized "Cultural Obliteration", the image disintegrating before our eyes. They encompass images that are specifically Jewish but not only related to the Holocaust, as in "Hidden"—which could refer to any of the times, places and ways in which Jews have hidden their identities, but in reading the Hebrew inscribed across the background (the words are "stories of children") we realize that she has in mind children hidden during the Holocaust, whether in convents or attics. They also encompass images of those victimized by the Nazis for other than their Judaism, (gays, for instance, signified by the pink triangle), as well as specifically Jewish victims, signified by the yellow star—placed like a guillotine blade at the base of the neck which supports a disembodied face.

The yellow stars themselves—turned white, and gray, and black—are the medium of **Sam Erenberg**. Scores of them, made of sewn felt, float, like leaves, and stick along the wall and ceiling and floor. It is as if, with only a few here and there on the wall (where we *expect* to see art hanging), but many more piled on the floor, the tree of Jewish life has been stripped of too many of its leaves, fallen to the ground as we enter the Holocaust winter. It is as if, undefeated by endless winters, the Jewish plant still flourishes: the few stars on the wall are the blossoms of spring, rising out of the earth toward the ceiling sky. It is as if each one represents a soul—or an almost infinite number of souls—and they rise to and through the ceiling *to* the sky.

For **Judy Herzl**, it is not the leaves as much as the trees from which they have been stripped and the forest from which the trees come that are multiply evocative of the Holocaust. They call out to those marched out into the woods to be executed without human witnesses. But the trees themselves in those many woods across Europe *were* the witnesses, standing silently, passively—as silent and passive as so many humans beyond those forests were. Forests were also redemptive witnesses, as they *hid* those fleeing from or fighting against the Nazis. More broadly, forests are also the setting for diverse questions (if a tree—or a body—falls in the woods and there *is* no human witness, does it make a sound?) and tales across the panoply of human cultures, with both positive (fairy god mothers) and negative (wolves and brigands) connotations. Works like "Forest of Witnesses" and "I Question" reconfigure the elements of nature, thus posing questions regarding the human role in shaping our world. But more than that, they impose upon us a sense of query: "I Question" neither asks for nor offers hidden texts or carefully worded answers to why we humans are as we are, or why what we are includes both the making of art and the making of crematoria. Partial faces and leafless trees require of us a wordless *kaddish* with regard to the Holocaust, but also a silent inquiry with regard to the larger human issues of which the Holocaust is an intensely troubling subset.

For **Geraldine Fiskus**, it is also the trees—as metaphor. They grow from and are depicted upon gravestones, within which the double question of past and future is embedded. Gravestones simultaneously separate and connect the living to the dead and the past to the present, in all cultures. For Jewish culture, visual self-expression is particularly rich in the old Jewish cemeteries of eastern Europe, many of them decimated during this century, due to the Holocaust or the Soviet depradations which followed the Holocaust. *"Through metaphor they reveal family and religious values which were the locus of community life. As reinventions."* Fiskus' paintings of details from gravestones or of groups of entire stones, *"continue the Yiddish culture which ended with the Holocaust".*

Her series, *Reinventing the Visual Language of Jewish Stelae of Eastern Europe*, is of interest not only for its aesthetic merit and her unusual method of black underpainting, lending a dark luminosity to her paintings. She reflects the persistent focus on the Jewish past in general and the Holocaust in particular for contemporary Jewish artists. Works such as "Stele IV: Birds and Fallen Branches," allude to *"a profound sense of losing a world which I actually never had… the cut limbs resonate the forced separation of Jewish families; the transports of young children taken from their mothers to the death camps."* The tree of Jewish life is not uprooted, in spite of constant deracination. It is truncated, but it continues to grow – but the distant and more recent past both point toward the present and ask: whither?

For **Alan Berliner**, it is not trees, but stones. Large stills from his video installation, "Gathering Stones," freezes projected video sequences of delicate portrait photos from the archives of the JDC (which organization relocated refugees after the war, among other things) onto the open "pages" of a large "album". The album is made from a bed of stones: two large fields of small black pebbles against which five (the number is the number of books of the Torah) smaller rectangles of white stones are placed. The haunting effect is as if the faces are made up of tiny pieces—or leaves, in fact, which is the illusion the stones offer to the eye—intact and yet broken (a paradox expressed again and again in work by Jewish artists) by myriad tiny cracks and crevices. The pebbles also evoke the centuries' old Jewish tradition of leaving tiny stones on the grave before leaving a cemetery, (we have circled back to the first work discussed in this narrative, by Marcia Reifman) as a concrete symbol of having *been* there, of marking remembrance and continuity, with the individual who has died and with the sweep of history and culture of which s/he is part—of connecting past to present, individual to community and dead to living.

For **Frank Ettenberg**, the landscape of the Catastrophe is too enormous to be encompassed other than by abstraction. "Passing through Europe" suggests an endless graveyard. If the repeating patterns of yellow suggest the imposition of that color on Jews not only by the Nazis during the Holocaust, but at prior times and places, the repeating crosses suggest the specific, personal sense of Christian presence that the artist carries abroad from home: *"As I live and paint in Catholic new Mexico, I can visualize Georgia O'Keefe's 'Cross at Night' any old time, and for that matter, I confirm that Christian iconography made a*

great impression on me as an art student." So, too, the "Study for a Monument to European Jews" suggests the inversion/transformation of a gigantic pyramid—most stable of geometric forms—by mirroring itself, as a diamond resting on its lower point, and thus doomed to topple over. Western civilization begins with the pyramids; our pretense at having followed a continuous ascent ever since ends with the Holocaust.

*The Inner and Outer Edges
of Word, Image, and Idea*

THE INNER AND OUTER EDGES OF WORD, IMAGE, AND IDEA

The Jewish experience is broad and filled with positive and dynamic concerns and diverse participation in the world. If we observe that many artists turn to and from the Holocaust as a major focus, and others wrestle with particular issues within Judaism, such as the role of women within traditional ritual, others turn to other aspects of Jewish experience. One of the more apparent features of Jewish life throughout history is its textual focus. We have observed Helene Aylon's particular address of Judaism's textuality, and each of Saul Balagura's images is accompanied by poetry. So we may note how **Avraham Eilat** literalizes the emphasis on the written word by encapsulating portions of Judaism's foundational text, the Torah, in sardine cans. The sacred word is circumscribed by the most banal of frames. Jewish life, like "Jewish art" is fraught with dynamic contradiction. In a second body of work, he follows almost the opposite course, abstracting the sweep and flow, the rise and fall of a landscape that is both universal and specifically war-torn: Europe after the Holocaust? Israel throughout its fifty-year history? Endless human history?

Madelin Coit turns text into art, and reality and illusion intermix in books that are and are not books. "Rose" is a pop-up book—because its pristine white surfaces are, as one unravels them, overrun with text—reflecting on the artist's mother, through whose *"mother's milk [came] the process of loyal lifelong commitment to an area of interest"* which includes Jewish history and culture, and a wide spectrum of other foci. "Promises IV" twists the issue of word vs image still further: a kinetic steel sculpture, it opens up into the form of a book—but *without* words: if the viewer must participate by approaching to initiate the process of opening-up (thus continuing the process of active viewer-participation that began, in western art, with the impressionists) s/he must also fill in the blanks, creating the text in his/her mind to cover the shining silver-colored metal. "The Big Bamboo" tells a story on a venetian blind: when the blind is opened, the story is invisible; when it is closed, we can see it.

We are on the multiple edges of art/text, image/word, inside/outside, opened/closed, revealed/hidden—all essential doublet aspects of the Jewish experience. *"[My work] has been accepted as strong thoughtful male. It has been rejected as too female. ...After writing reams on influences: Ishtar/Ashtarte religion; early Judaism; the movement of Jews to*

Spain, Portugal, Morocco, Poland, Lithuania, Germany; the Industrial Revolution; W.W. II; the electronic revolution; Jewish life in the U.S.A.; the reappearance of women as possibly sentient humans—The conclusion… is that the process of loyal life-long commitment to an area of interest, to the thought and product of research came to me with my mother's milk. Because of RNA/DNA my focus is called art. The same commitment is ordinarily made [in the Jewish tradition] *to Torah. My research is through color, line, texture, shape and running through it all is an old thread demanding an awareness of past and a responsibility to future – an accountability. But I could say the same of committed artists who are not Jewish – now, that's Jewish."* Her words articulate the range of syncretistic possibilities that define the indefinably Jewish in art.

Jane Logemann's work is layered with *rows* of letters and words over which subtle pigments are washed. They may be viewed as abstractions (particularly if one doesn't read the Hebrew, Arabic, Japanese, Russian and other writing systems that she uses), while at the same time they may be read (literally) in terms of their content and message. The word has become the image: the ongoing repetition of a word, run together so that its beginning and end points are not apparent—and so it is also simply as if the letters and not the words are repeated end-lessly. This suggests the patterns of sound-and-syllable repetition prescribed for the mystic in some kabbalistic systems. The *sense* of the words is lost within the patterns that carry the mystic toward union with the realm of *non*-sense. But the ongoing rhythmic patterns also recall contemporary music (Philip Glass, for instance), ancient Byzantine mosaics, Islamic art and some of the painting of Sol Lewitt (who was her teacher)—thus embedding specific Jewish concerns within universal ones.

The visual distinction between, say, Hebrew and Japanese scripts in the repetition of her *Legal Terms* series (1992)—"Discipline", "Debate", "Logic" and "Procedure" are in this exhibit—invites the viewer to consider the wide range of similarities/differences between two languages, two cultures, two patterns of thinking and being. The implications for *legal* systems, as opposed to more general socio-cultural systems is yet more complex. Conversely, "Border T" (1998) is part of a series that subsumes all such issues into the complex simplicity of pure abstract aesthetics.

Allan Wexler's "Tzedakah" takes a term from Jewish vocabulary—it is commonly translated as "charity", but means "righteousness" and is thus intended to have broader and deeper implications than reaching into one's pocket—and turns it outward toward the viewer. He uses the centrality of that Jewish concern to observe this concern outside Judaism, presenting his "alms kits" contrived with cans of food reflecting different languages/cultures/traditions (they all have traditions of charity) to the viewer to put together—these are *do-it-yourself* charity kits. He thus invites us to think about the universal need and importance of charity outside the gallery space where we merely participate in an art installation. The gallery installation—as all art—is ultimately inspired (in-spirited) by the Divine work of art of which humans are the culminating aspect, charged to have stewardship over others by the God of *Genesis*.

Stewardship is at the center of **Gay Block**'s series, *Rescuers*. We see one face after another of non-Jews who, in the course of the Holocaust, at considerable risk to themselves, rescued Jewish would-be victims of the Nazis. I am particularly drawn to "Reverend Mediema" because he stares at us with such an austere expression, cigarette in hand, that, without a title I would have thought him a killer of Jews, not a savior of Jews—which demonstrates eloquently how appearance can be deception. Block's second series in this exhibit focuses this very idea. Her *Clothed/Nude* diptychs[7] offer individuals who face us literally both clothed and unclothed. The settings and poses are varied but inevitably dramatic, and suggest the dynamic edge between what we reveal and what we conceal with and without our clothing; what role clothed appearance makes through the course of human history; clothes as the uniform that defines our place, to others, within our culture or society—or a rebellion against placement. Block turns us out, as Wexler does, from the specifics of being a Jew in the world to the endlessly diverse patterns of being *whoever* we are in the world.

Cynthia Madansky's installation—this exhibit presents only part of it—asks the textual question of who and what Jews are in the world in terms that non-Jews have used for centuries. "On the Jewish Question " is a now-famous essay written by Karl Marx, in 1843-44, in response to writing by Bruno Bauer on that subject. Marx himself was born Jewish, was baptized (and therefore converted) by his upwardly-mobile lawyer father when Karl was 6 years old, and spent summers out in the country with his very Orthodox grandparents while he spent the school year in the city with his nominally Christian parents. In short, he cannot have failed to grow up with deep confusion regarding his identity, and not surprisingly, addressed a question being much-discussed in post-Emancipation (more correctly: on-again-off-again-Emancipation) Germany, but which would have had a strong personal resonance for the young scholar (it was the first subject on which he wrote after receiving his PhD). Marx's essay has been variously interpreted as a defense of Jews and as virulently antisemitic.

Which doesn't mean that it couldn't be both. In any case his equation of Jews with "huckstering" and his association of the capitalist ills of society with Judaism most particularly reflects a distortion toward stereotype. It suggests both his ignorance of the conditions of Jewish history and the absorption of a popular view without examining its reality. It is thus both a stark symbol of the unresolved nature of the Jewish condition in the modern world and of the way in which Jews themselves may be wont not to apply the same clarity of thought or quality of research or compassion to themselves as a group which they apply to others. Madansky takes the text—literally—and beats it into panels which are illegible, scarred and distorted. The panels look remarkably like the metallic plates used to print paper money; they shimmer like giant square coins. They cut us concisely with the edge of their commentary on Marx, on the Jewish Question, on the margins between Judaism and Christianity and on textuality and visual art—since they are both and neither of these.

VIII

The Edge of the
Jewish Artist's Selves

THE EDGE OF THE
JEWISH ARTIST'S SELVES

Which leads to what is, not surprisingly, a subject that has focused the visual and conceptual attention of Jewish artists particularly in this century—and offers an obvious "edge". That is: where do I as a Jewish artist fit into the history of western art, when for the past 16 centuries *western* art has largely been *Christian* art? Do I simply understand Massaccio and Piero, Michelangelo and Raphael as Christian artists do or, when so much of their subject matter reflects a Christian sensibility, do I see these artists' work differently from my Christian colleagues? We see the expression of these implied questions articulated in various ways. **Susan Schwalb**'s *Creation* series, for example, is a series of triptychs. But the artist has redefined that most Christian form of visual self-expression, with its triune symbolism, in Jewish terms (we have completed a circle back to Barnett Newmann): the general terms of non-figuration and the specific historical terms of the most famous of medieval Jewish illuminated manuscripts, the fourteenth century *Sarajevo Haggadah*. Her technique revives the Renaissance penchant for silver point and copper point and weds it to the medieval use of gold leaf — but in completely abstract compositions inspired by the opening images in the *Sarajevo Haggadah*.

In most of the works in Schwalb's series six small circles and a significantly larger seventh circle swirl in silverpoint against an earth-brown and/or a dark or light (night or day) sky blue background, the whole edged by a white gold leaf frame. Creation has been re-visioned in the abstract geometry of the circle (without beginning and without end). *"I am obsessed by the extraordinarily tenuous line of silver point; it has been my primary medium since 1974. I use thousands of fine lines to obtain a luminous surface in each picture... When I first came across the Sarajevo Haggadah I was powerfully stirred to find images of arc and circle... Unlike familiar Christian portrayals of the creation, the image of God is not represented. But sun, moon and earth are clearly rendered by circular forms..."* she wrote in 1993.

Certain of Schwalb's works add to the arc-circle configuration a downward-pointing triangle with vertical line from mid-base to apex. This symbol of femaleness is traceable back to Neolithic art. The role of artistic creatrix so long suppressed for women is restored, as the role of Jewish artist is addressed, in the very textures of the silver point surface she works.

Thousands of fine lines engender an active energy—flesh-like, water-like, sky-like—within the static confines of the framing forms. The watery, wave-like lines of the silver point surface within the tumescent frame suggest the amniotic fluid of the womb which connects the birth of humans to the birth of fine art and the birth of the universe.

The celebration of the fertility of that universe is at the center of the Jewish festival of *Sukkot* (the Feast of Booths), which also recalls the passage from Egypt to the Promised Land, during which forty-year wilderness journey the Israelites dwelled in temporary booths. **Ted Egri**'s bronze work, "Sukkot", as much as it overtly records a tender moment of inter-generational continuity, so essential to Jewish self-consciousness, also invokes the familiar image of the Madonna and Child. He has transformed a recognizable Christianate image into one of specific Jewish significance. The Christ Child in his Mother's arms, reaching for the grapes that symbolize his future martyrdom (grapes as blood and therefore as sacrifice) becomes a Jewish baby reaching, within the *sukkah*, for the grapes that symbolize the joy associated with the seasonal and generational continuity of Jewish celebration.

Susan Ressler has synthesized the triptych form to the visual investigation of a Jewish holiday and specific questions regarding the role of women in her "Vashti's Tale: A Modern-day Bestiary." Vashti is the Queen disposed of by King Ahasuerus when she refuses to entertain him and his pals in the midst of a month-long drinking party; her demise clears the way for the heroine, Esther, to appear on the stage. How precisely to understand both Vashti (as a feminist heroine?) and Esther (as the first diasporatic Crypto-Jew?)—and how to understand the interweave of politics and spirituality in the text of the Book of Esther—transfixes the artist. Analogous concerns define her *Missed Representations* series. "Expulsion"; for example, offers a small triptych the middle panel of which is a detail from Massaccio's "Expulsion". Adam and Eve are leaving the Garden of Eden in anguish, conveyed by their sucked-in stomach muscles and the expression in the deep dark eyes of Eve—who is perceived as the primary perpetrator of the Expulsion-inducing crime, in the Judaeo-Christiano-Islamic tradition.

Having gained awareness of their sexuality by consuming the forbidden fruit they attempt to cover their nakedness. Ressler has flanked this image with those of two contemporary models in bathing suits (whose body language, moreover, echoes that of Massaccio's Eve) and one of whom wears a bathing suit upon which a serpent slithers as a decorative motif. The models are all but unidentifiable as specific people: they are reduced to advertising armatures for bathing suits and/or to enticing sexual entities, sexual objects. So an icon from western art and the Judaeo-Christian theological tradition (Massaccio's painting) within a Christianate theologico-aesthetic structure (the weight given to sexuality within the context of the Expulsion and the triptych form) is synthesized to an icon from the modern visual world (bathing suit advertisements) and the long-term historical pattern of objectifying women.

Nor is it only the western/Christian world which offers a historical and cultural context and thus cultural and spiritual questions for Jewish artists. **Hank Saxe** and **Cynthia Patterson** (he born Jewish, she converted to Judaism – so they approach that center from

different edges) explode along the upper part of the wall and onto the ceiling with a profusion of ceramic tiles that are inspired by the Islamic tradition of repeating geometric forms. The interweave of infinitizing and finitizing qualities, rectilinear and curvilinear elements, of antithetical colors, of geometric and vegetal motifs—all within the strictures against figurative representation that Islam adopted and adapted from the Jewish visual tradition—symbolizes, in that tradition, the paradoxically antithetical *interweave* between Allah and ourselves. Moreover the ascent of such patterning towards the light as in "Ladder/Shadow/Light" suggests the further connection between the biblical story of Jacob's dream of a ladder connecting heaven and earth and that of *"the many kivas built on the Pajarito Plateau surrounding Los Alamos... The ladder image expresses a connection between the subterranean worlds in Pueblo thought, the surface we occupy and the consciousness that Jacob was tapping into in his vision."* The viewer is mesmerized by dynamic synthesis.

Rudolf Baranik's work summarizes much of this discussion. His work carries us back, with Schwalb's, to Barnett Newman and the abstract expressionists—for it is, visually, in part, a continuation of that era and that aesthetic sensibility. But whereas the abstract expressionists' social concerns, Jewish and otherwise, are usually buried beneath interpretation, the seamless relationship between the poetry of Baranik's painting and his politics is nearly always brought to the surface. Abstraction is not so absolute that a pale skull cannot be discerned again and again in his various series on human-contrived horror, such as the *Napalm Elegy* series. Thus he may be viewed in terms pertinent to so many other Jewish artists, from Shahn to Klinghoffer, whose social conscience drives their work outward in an array of socio-political directions. In some of Baranik's paintings, the overrunning of the surface with words, words, words relates his painting, as well, to those artists whose work dances on the edges between text and image, and text reduced to abstract image, and visual repetition as an engagement of varied mystical and musical traditions.

The range of Baranik's interests is echoed by the compendious volume and variety of his work. For ultimately an artist creates out of his/her own experience and sense of self, and few artists are limited to one aspect of self. **Karl Plansky**'s self-portraits are both singular and multiple. Bound and gagged or as various opera divas they overpower us with their fearsome brushwork and color, their raw emotion. As an adolescent, *"not only did I fail to relate to Santa Claus, the Easter Bunny, and the stereotypical image of the heterosexual American male, but I could find no way of incorporating them into my profound sense of being Jewish. Early on I discovered that painting was the only way I knew of addressing these contradictions. My search for subject-matter in painting has always been a search for identity. Paint and canvas have functioned as a metaphor for the world in which I as a 'wandering Jew' might find a home... I dress myself in costumes and make-up, look in the mirror, and explore the resulting physical and emotional transformations through the paint... I feel that I am mirroring the ways in which Jews have changed identities in order to assimilate and exist, while at the same time maintaining a constant,*

underlying Jewish identity. . . . new identities on the canvas do not represent obfuscations or conversions, but ways of synthesizing the outer world with my authentic self, which is Jewish, American, and gay."

In speaking of finding a home, Plansky's words about his art bring us back to where the specifics of this discussion of multiply-aspected identity began. The fifty artists represented here encompass an astounding range of styles and issues, of changed aesthetic identities "while at the same time maintaining a constant, underlying Jewish identity." Whether it is recognized as literally expressed within their work or as a metaphor for other aspects of their own lives and the life of the world around them, what all of these artists share is the high quality of their artistry and the sense that being Jewish is somehow a factor in honing the myriad facets that make them artists and human beings to a fine cutting edge.

Notes:

1. Unless otherwise noted, all quotes from artists are drawn either from the statements submitted with their work or conversations between them and the author.

2. It is a symptom of the dynamic possibilities of interpretation that I view Newman's work, and in particular his "zips" from exactly the opposite perspective expressed by Donald Kuspit in his essay: rather than suggesting a separation, I see the strip of light as drawing the eye irresistibly toward it as a centering element, thus effecting *tikkun olam*, pulling back together a world that has been blown apart. But I don't see our interpretations, by paradox, as mutually exclusive, even as they are apparently antithetical.

 For further discussion of Newman as well as other key Jewish chromatic expressionists like Marc Rothko and Adolph Gottlieb, see my video course, *Tradition and Transformation: A History of Jewish Art and Architecture*, segment 9b, Cleveland: Electric Shadows Corporation, 1984-90 and my essays in the exhibition catalogue of *Faith* at the Aldrich Museum, Ridgefield, Conn, 1999-2000 and the exhibition catalogue of *Like A Prayer: A Jewish and Christian Presence in Contemporary Art* at the Tryon Center for Visual Art, Charlotte, NC, 2001.

3. From a statement prepared for a brochure on Tobi Kahn created by Litwin Gallery, Wichita, Kansas, in 1992.

4. In his artist's statement for the exhibition at the Jewish Museum, New York, Jewish Themes/Contemporary American Artists, July-November, 1986.

5. Logistical considerations have necessitated the substitution of other work for the Yeshiva University Museum venue.

6. Logistical considerations have necessitated the substitution of other work for the Yeshiva University Museum venue.

7. Logistical considerations have necessitated the substitution of other work for the Yeshiva University Museum venue.

Jewish Artists: On the Edge
Curator: Ori Z Soltes
Project Director: Jay Barry Zeiger

Cooperating Sponsors
Jewish Community Council of Northern New Mexico
Anonymous
Allan and Mary Swartzberg
SITE Santa Fe—Art and Culture
The Marion Center
The College of Santa Fe
Yeshiva University Museum

Sponsors
Marlene Nathan Myerson

Patrons
Anonymous
Ted and Barbara Flicker
Leah Kellogg
Vivian Margolis/Camas de Santa Fe
New Mexico Endowment for the Humanities
Dr. Robert Rubenstein
Donald Tishman
Perimeter Gallery, Chicago
Center for Jewish Culture and Creativity

Benefactors
Ursula and Saul Balagura
Sam and Ethel Ballen
Philip and Gloria Cowen
Fred Kline Gallery
Levin Family Foundation
McCune Charitable Foundation
Robert Spitz and Illona Klein
Zaplin-Lampert Gallery

Friends

Jim and Frieda Arth
Max and Diane August
Alvin and Arlene Becker
Samuel and E Judith Berger
Black Mesa Vineyard
Stuart and Brenda Brand
Richard and Helen Brandt
Lewis and Marilyn Cohen
Jill Cooper/The Marketplace
Jack and Lisa Copeland
Ira and Ann Dermansky
Samuel J Erenberg
Frank Ettenberg and Silvia Stenitzer
Ted Egri
Rachel Giladi

Pat Hall
Fred and Shirley Klinghoffer
Paul and Ruth Kovnat
Geoffrey F Laurence
Donald A Meyer
National Distributing Company
Ron Pokrasso and Mary Ann Shaening
Paul and Blanche Postelneck
Rachel Rosen and Barbara Zusman
Martin and Beatrice Schultz
Ernest and Edith Schwartz
Matthew Schwartzman/The Candyman
Susan Schwalb
Pierre D. Seronde
George Wardlaw

**We also thank the following individuals
who provided their homes and gracious hospitality for fundraising:**
Ursula and Saul Balagura
Madelin Coit and Alan Levin
Rabbi Malka Drucker and Gay Block

ARTISTS INDEX